IMAGES
of America

MADE IN CHICAGO
THE WINDY CITY'S
MANUFACTURING HERITAGE

D1592878

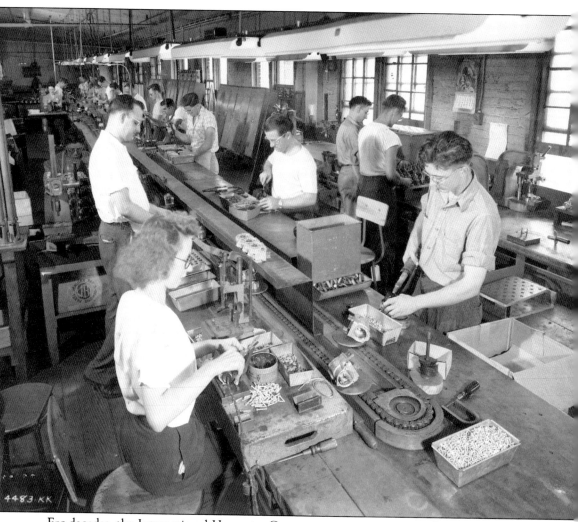

For decades, the International Harvester Company was synonymous with manufacturing in Chicago. Between 1847 and 1972, it operated large, vertically integrated factories in the city that made agricultural equipment and employed thousands of people. (Courtesy of the Wisconsin Historical Society, WHi-52220.)

ON THE COVER: This 1947 photograph shows an assembly line inside International Harvester's plant in the West Pullman neighborhood on the South Side of Chicago. (Courtesy of the Wisconsin Historical Society, WHi-52010.)

IMAGES
of America

MADE IN CHICAGO
THE WINDY CITY'S
MANUFACTURING HERITAGE

Austin Weber

ARCADIA
PUBLISHING

Copyright © 2019 by Austin Weber
ISBN 978-1-4671-0307-7

Published by Arcadia Publishing
Charleston, South Carolina

Printed in the United States of America

Library of Congress Control Number: 2018959905

For all general information, please contact Arcadia Publishing:
Telephone 843-853-2070
Fax 843-853-0044
E-mail sales@arcadiapublishing.com
For customer service and orders:
Toll-Free 1-888-313-2665

Visit us on the Internet at www.arcadiapublishing.com

To Katherine, for her love, guidance, and patience

CONTENTS

ACKNOWLEDGMENTS

This book would not have been possible without the assistance of many individuals. I am grateful to the people and organizations who provided materials and support.

The entire staff of the Chicago History Museum was always helpful during the multiple visits that I made to that organization's world-class research center to peruse books and access its vast collection of vintage images.

Linda Bullen of the Pullman State Historic Site; Sheldon Hochheiser and his colleagues at the AT&T Archives and History Center in Warren, New Jersey; and Lisa Marine of the Wisconsin Historical Society in Madison, Wisconsin, assisted me with their organizations' large photograph archives.

Several individuals also allowed me to peruse their collections, including Noel Abbott of the Epstein architecture company; Mark Mattei, a longtime bicycle dealer on the North Side of Chicago; Dennis Schlagheck, author of a book about the Hawthorne Works; and Rod Sellers of the Southeast Chicago Historical Society.

Other special thanks go to Don Glasell of the Chicago Maritime Museum; Jacob Kaplan of Forgotten Chicago; Dennis McClendon of Chicago CartoGraphics; Art Peterson of the Krambles-Peterson Archive; and Robin Pearson of Nynehead Books.

The Special Collections and Preservation Division staff at the Harold Washington branch of the Chicago Public Library helped me access their amazing collection of old trade catalogs and literature. And, during my visit to the Benson Ford Research Center at the Henry Ford Museum in Dearborn, Michigan, librarians allowed me to peruse the archives of the A.B. Dick Company.

I visited several suburban historical societies and was impressed by their eclectic collections. In particular, I would like to thank Heather Bigeck at the Joliet Area Historical Museum; Jennifer Bridge at the Naperville Heritage Society; Elizabeth Marston at the Elgin History Museum; Beverly Millard at the Waukegan Historical Society; and Nancy Roozee and Craig Pfannkuche at the McHenry County Historical Society in Union, Illinois.

Other organizations that supplied images for this book include the Elgin, Joliet & Eastern Railway Archive; the Library of Congress; the Newberry Library; the Ryerson & Burnham Archives at the Art Institute of Chicago; and the special collections department at the University of Illinois at Chicago Library.

Also, special thanks go out to Boeing, Fiat Chrysler Automobiles (FCA) US LLC, Ford, General Motors, Lyon & Healy, Radio Flyer, and S&C Electric for providing photographs from their corporate archives.

Images without a parenthetical credit line are from the author's collection.

INTRODUCTION

If you ask most people to name a city or region in the United States that is associated with cars and trucks, Detroit will likely come to mind. Shoes and garments? New England. Furniture? Grand Rapids. Steel? Pittsburgh. Electronics? Silicon Valley.

But, only one city was a leading player in all of those industries, along with many other product categories: Chicago.

Once upon a time, few cities could match Chicago's production prowess. The typical American home, school, and office contained numerous products that were proudly stamped with "Made in Chicago, USA."

Homes contained Chicago-made appliances, furniture, lamps, pianos, radios, televisions, and telephones. Offices used locally produced adding machines, hole punches, mimeograph machines, pencils, postal scales, staplers, teletype machines, three-ring binders, and typewriters.

Kids rode bikes, used sporting goods, and played with toys made in the Windy City. At school, they used chairs, desks, lockers, and pencil sharpeners manufactured by Chicago companies. And, they watched educational movies and film strips on projectors made in the city and surrounding suburbs.

For much of the 20th century, Chicagoland was a manufacturing mecca, due to its central geographic location and ready access to rail and water transportation. Chicago was one of the largest and most diverse manufacturing regions on earth. In fact, the city even dominated the field of globe making thanks to local firms such as Denoyer-Geppert, George F. Cram and Company, Rand McNally, Replogle, and Weber Costello.

During the late 19th century and most of the 20th century, manufacturing was the heart and soul of Chicago. Blue-collar factory jobs kept the city humming 24 hours a day. The local landscape was dominated by large, multistory brick factories topped with water tanks. Many of the buildings were local landmarks to generations of Chicagoans.

On the North Side of the city, you could not drive down Diversey Parkway without seeing the giant headquarters of Stewart-Warner, a top manufacturer of products ranging from automobile speedometers to refrigerators.

Speaking of appliances, the West Side of Chicago was once home to factories that mass-produced everything from irons and toasters to ovens and washing machines at companies such as Hotpoint and Sunbeam.

On the South Side, there were massive complexes operated by long-forgotten companies such as International Harvester and Pullman. Tractors and train cars rolled out of their factories every day. Steel mills and metal fabricating shops lined the banks of the Calumet River on the city's gritty Southeast Side.

The suburbs of Chicago also contained giant factories of their own. Within a few blocks along Touhy Avenue in north suburban Niles, there were A.B. Dick, Bell & Howell, and Teletype. In the western suburbs, factories ranged from Western Electric's Hawthorne Works in Cicero to the

Elgin National Watch Company. South suburban Harvey was home to large employers such as the American Stove Company and the Buda Engine Company, a preeminent manufacturer of gasoline and diesel engines.

Thousands of men and women in Chicagoland once worked on assembly lines, in foundries, and at machine shops. Those factories provided a steady paycheck to recently arrived immigrants. They put food on the table and enabled people to purchase homes or send kids to college.

Manufacturing in Chicago began quietly with a few small blacksmiths and chair makers who set up shop shortly after the city was officially established in 1837. One of the first commercial enterprises was a small factory that made cabinets. It opened on Lake Street in 1839 and was run by Augustine Bates and Caleb Morgan.

Chicago's industrial development was kick-started by the arrival of a 38-year-old inventor from Virginia in 1847. Cyrus McCormick opened a small factory on the north bank of the Chicago River to mass-produce horse-drawn farm implements. The McCormick Reaper and Mower Works soon became the city's largest manufacturer and one of its biggest employers.

McCormick produced only 450 mechanical reapers in 1847, but within two years, he was making 1,400 machines annually. Production surpassed 5,000 units in 1859. By the time of the Great Chicago Fire in 1871, the product line was expanded, and annual production jumped to just shy of 10,000 machines.

Other innovators and entrepreneurs from the east followed in McCormick's footsteps and set up shop in Chicago. For instance, John Brunswick relocated from Cincinnati in 1848 and began manufacturing billiard tables. In 1855, toolmaker Mathias Klein arrived from Philadelphia and started to produce pliers in the Windy City. That same year, Richard Crane moved west from New Jersey and set up a small foundry to make brass bells, copper lightning rods, and steam engine parts.

In the mid-19th century, Chicago was a manufacturer's dream. The city was easily accessible by lake, river, and canal. Barges and schooners clogged Chicago's waterways and exchanged goods with railroads that branched out in every direction.

The city quickly became the center of the wholesale lumber industry, with hundreds of acres of lumberyards hugging the south branch of the Chicago River. By 1870, more than 200 boats loaded with white pine imported from the forests of Michigan and Wisconsin were arriving every 12 hours, clogging the local waterways and making Chicago the busiest port in the United States.

Because of that abundant supply of lumber, Chicago soon emerged as a foremost producer of wooden railroad cars, ships, carriages, and wagons. The city also became the nation's leading manufacturer of agricultural equipment, furniture, organs, and self-playing musical instruments.

During the mid-19th century, most factories lined the banks of the Chicago River. And, 80 percent of the firms operated within three miles of the intersection of State and Lake Streets. Downtown Chicago was dominated by companies that made clothing, furniture, carriages, and wagons.

But, the number of manufacturers in the Loop steadily declined between 1881 and 1924. For instance, in 1843, Peter Schuttler opened a small wagon factory in a one-story wood-frame building at the southwest corner of Randolph and Franklin Streets. He later operated a facility on the northeast corner of Monroe and Clinton Streets before eventually relocating to a much bigger factory at Twenty-Second Street (Cermak Road) and Rockwell Street that the company proclaimed was "one of the largest and most commodious in the country, fully equipped with up-to-date machinery."

Several railroad car manufacturers were also established in the Windy City during the mid-19th century. Two early players in the industry were the American Car Company, which produced 700 freight and passenger cars in 1853, and Union Car & Bridge Works, which made 400 railcars in 1854.

The golden age of manufacturing in Chicago lasted from approximately 1872 (a year after the Great Chicago Fire devastated the city) to 1972. Manufacturing in the city reached its zenith in 1947, when employment peaked at 667,407 workers.

In the late 1940s and early 1950s, many manufacturers moved their operations to nearby suburbs such as Des Plaines, Franklin Park, Niles, Skokie, and Melrose Park. Companies replaced old, multistory factories in the city with modern, one-story buildings that improved production flow, made better use of floor space, and increased efficiency.

Chicago once excelled at producing a plethora of products. The city's forte was casting, forging, and stamping metal parts that were then turned into finished products. Other facilities made cardboard boxes or plated electrical and electronic components. Large manufacturers were supported by a vast network of smaller companies that supplied them with parts and subassemblies, such as brackets, nuts, rivets, screws, springs, and wiring harnesses.

The daily output from these diverse factories was mind-boggling. In its prime, the Chicago area produced more bicycles, pianos, pinball machines, radios, and televisions than anywhere else on the planet.

For decades, mail-order firms based in Chicago, such as Montgomery Ward and Sears, kept local factories busy, producing hardware, kitchen appliances, sporting goods, tools, toys, and watches.

At one time, more than 50 percent of all telephones in the world were assembled at the sprawling Hawthorne Works.

There were 29 shoe factories in Chicago in the 1920s, with more than 4,500 workers producing almost nine million pairs of shoes annually.

In the 1950s, Chicago manufacturers, such as Mead Cycle and Monark Silver King, mass-produced bicycles. And one out of every four bikes sold in the United States was a Schwinn built on the West Side of Chicago.

Pianos were first built in Chicago in 1884. But, by 1906, local companies were mass-producing 25 percent of the US total. Another 30,000 instruments were made within proximity to the city. South suburban Steger was the self-proclaimed "piano capital of the world" because local factories shipped an average of 100 units a day in the 1920s.

Chicagoland also excelled at making all types of furniture, ranging from upholstered living room items to commercial products like church pews, school desks, and office chairs.

In 1850, there were 13 firms in Chicago producing furniture. Within six years, the largest furniture factory in the city was Adams & Clark. It employed 60 men who turned out 18,000 bedsteads annually. Most items were shipped by rail to people in the expanding western part of the United States.

The number of furniture manufacturers in Chicago increased to 20 companies by 1860 and then quickly multiplied to 174 firms by 1879. In 1929, there were 286 companies in the industry. At the time, the Windy City accounted for more than 10 percent of all furniture production in the United States, employing more than 20,000 workers. Companies such as A.H. Andrews and S. Karpen & Brothers operated large automated factories along Cermak Road on the Southwest Side of the city.

Electronics was another industry that once thrived in Chicago. By the early 1960s, local manufacturers produced almost half of the consumer electronics made in the United States, including radios, stereos, and televisions. The industry accounted for about 140,000 area jobs, which made electronics the city's biggest manufacturing sector.

Unfortunately, manufacturing employment plummeted in the 1970s and 1980s for a variety of reasons, falling to 147,000 jobs in Chicago by 2000.

In 1972, International Harvester closed its massive Tractor Works on the Southwest Side, marking the end of its 125-year manufacturing presence in the city. Around the same time, local companies in the electronics industry began offshoring operations. For instance, in 1977, Zenith shifted production of circuit boards and other television components to factories in Mexico and Taiwan.

In 1982, Pullman shut its doors after 100 years of assembling railroad cars on the South Side of Chicago. That same year, Sunbeam announced that it was closing its large plant on the West Side of the city. At its peak, in 1958, the factory on Roosevelt Road employed 4,000 people.

More bad news came in 1983 when Schwinn closed its bicycle factory on the West Side and Western Electric shuttered its famous Hawthorne Works complex.

Despite that trend, Chicagoland continues to thrive as a manufacturing center today, generating billions of dollars toward the local economy and still employing thousands of people. It ranks as the nation's top producer of electrical equipment, fabricated metals, food, machinery, paper, and plastics.

Factories located within the city's borders have become much less common over the last few decades. But, notable manufacturers still active in Chicago include Ford Motor Company (Ford Explorer and Lincoln Aviator SUVs) in Hegewisch, Lyon & Healy (harps) on the Near West Side, and S&C Electric Company (electrical distribution equipment) in Rogers Park. Small machine shops and light manufacturing plants also thrive in many corners of the city.

In addition, Chicago continues to be on the cutting-edge of advanced manufacturing. For instance, Fast Radius on the Near West Side and Sciaky, Inc., on the Southwest Side are main players in the fast-growing field of industrial 3-D printing. On the North Side, Goose Island is home to the Digital Manufacturing and Design Innovation Institute, a state-of-the-art facility that specializes in developing next-generation production technology.

And Chicago regularly plays host to several major trade shows that attract thousands of manufacturers from around the world. Those events include the Assembly Show, the Automate Show, Fabtech, and the International Manufacturing Technology Show, which fills every square inch of McCormick Place with the latest production tools and equipment.

Old factories still dot the local landscape but serve a different purpose today. Many of them have been converted into commercial and residential lofts. Examples include the original Schwinn bicycle factory on Lake Street and buildings that once produced items such as Bell & Howell movie cameras, Eversharp pens and pencils, Florsheim shoes, Frederick Cooper lamps, Hart Schaffner & Marx suits, and Ludwig drums.

This book provides a peek behind factory gates and inside some of Chicago's long-forgotten assembly lines, foundries, machine shops, and steel mills. It covers everything from automobiles to watches and includes suburbs stretching from Waukegan to Joliet and Woodstock to Hammond.

One

WHY CHICAGO?

Chicago became America's manufacturing capital because of its strategic geographic location in the middle of the country. The city also provided manufacturers with easy access to rail and water transportation networks. Chicago was ideally situated at the foot of the Great Lakes and at the junction of important rail and water routes.

Two pivotal moments occurred a decade after Chicago was incorporated as a city. One was the opening of the Illinois and Michigan Canal in 1848, when the Windy City only had 20,000 inhabitants.

The canal linked the Chicago and Illinois Rivers together and provided a vital connection between Lake Michigan and the Mississippi River. Canal traffic up and down the waterways created an artery that stimulated the commercial growth of the city.

Waterborne trade made Chicago a center of commerce and the gateway to the western frontier. The city quickly developed into a major inland port that was serviced by many types of barges, frigates, schooners, and steamships.

The same year that the canal opened, another pivotal event occurred—the opening of the Galena & Chicago Union Railway. Although it initially only ran 10 miles west of the city, the railroad attracted the attention of investors who soon built other lines that radiated out in all directions, including the Chicago & North Western, Illinois Central, and Rock Island.

Eastern railroads, such as the Baltimore & Ohio, Michigan Central, and Pennsylvania, soon extended their tracks west to connect with the Windy City. By 1856, 10 trunk lines ended in Chicago, making the city an important transfer point for railroad freight traffic and waterborne trade.

Meanwhile, Chicago's population had risen to 100,000. Many of those people were recent European immigrants armed with valuable skills such as hammering metal or carving wood. The vast talent pool enticed entrepreneurs to open up a variety of factories and workshops.

A large number of those facilities were strategically located on the Chicago River or along the numerous railroad tracks that linked the city to markets in the East, West, North, and South.

That incredible transportation network quickly transformed the way that products were manufactured and distributed. It provided manufacturers with a convenient way to bring in parts, components, and raw materials. Rail and water transport also provided an inexpensive way for companies to ship their finished products nearly anywhere in the United States or Canada.

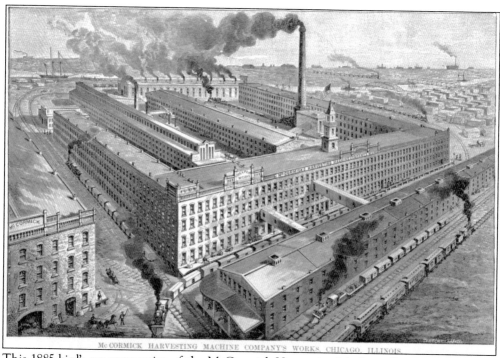

This 1885 bird's-eye perspective of the McCormick Harvesting Machine Company shows the important role played by railroads and water transportation in early Chicago. The stacks of lumber in the upper right corner were transported from Michigan and Wisconsin by schooner. Railroads provided ready access to parts and raw materials and then made it easy to ship finished products to customers around the United States. (Courtesy of the Wisconsin Historical Society, WHi-63083.)

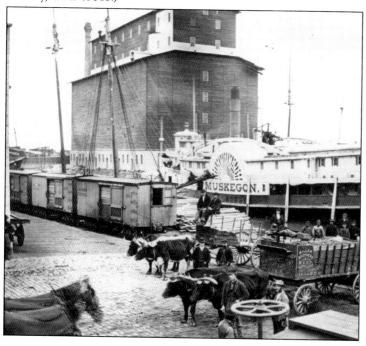

Busy scenes like this along the Chicago River were common in the late 19th and early 20th centuries when wood was an essential raw material for many early manufacturers. Because of the abundant supply of lumber, the Windy City became an important producer of wooden railroad cars, ships, and wagons. (Courtesy of the Chicago History Museum, ICHi-013999.)

Workers at the Crane Company plumbing fixtures plant on the Southwest Side of Chicago are loading a string of boxcars in this photograph from the early 1940s. Each crate of valves weighs more than 450 pounds and is stamped "Made in Chicago USA." (Courtesy of the Chicago History Museum, HB-27229-B, Hedrich-Blessing Collection.)

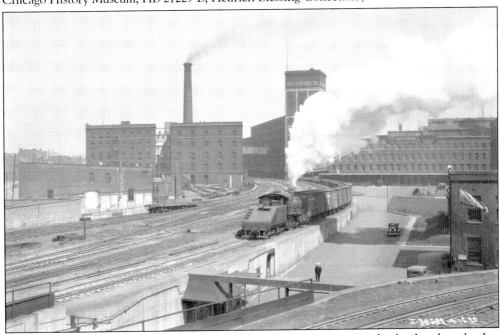

Many factories in Chicago were strategically located near a vast network of railroad tracks that linked the city to markets in the East, West, North, and South. This scene from 1929 shows a small part of International Harvester's McCormick Works in the background. (Courtesy of the Wisconsin Historical Society, WHi-9225.)

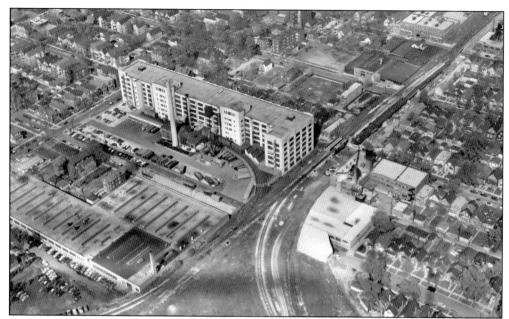

This aerial photograph of the Schwinn bicycle factory on the West Side of Chicago illustrates how manufacturers depended on railroads. The tracks running beside the building are part of the Bloomingdale Line, an elevated freight corridor that was lined with small factories. The bottom of the photograph shows part of the Milwaukee Road's Pacific Junction, which is located several miles from downtown Chicago. (Courtesy of Mark Mattei.)

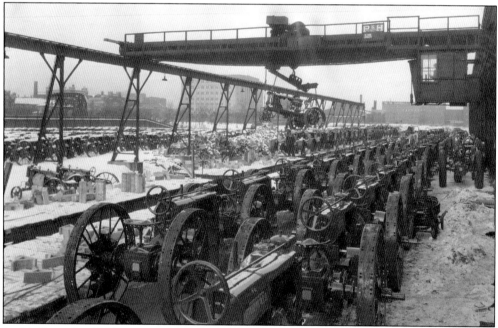

In this December 1934 image, rows of new Farmall F-12 tractors are lined up outside International Harvester's Tractor Works on the Southwest Side of Chicago. An overhead crane is used to load the tractors onto railroad flatcars for shipment to farmers around the world. (Courtesy of the Wisconsin Historical Society, WHi-8267.)

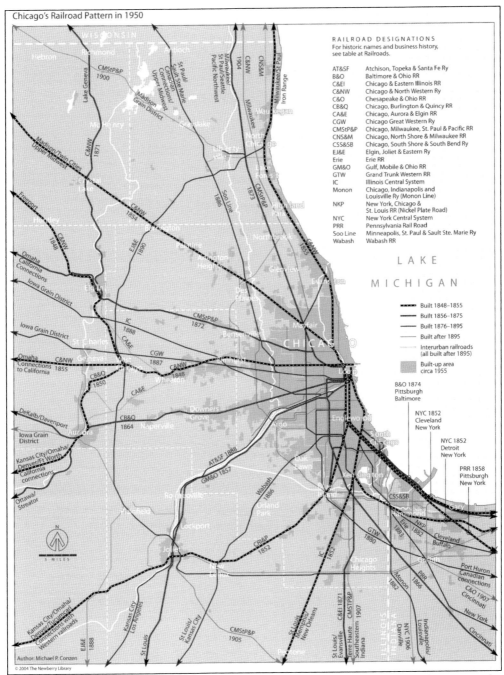

Chicago's Railroad Pattern in 1950

RAILROAD DESIGNATIONS
For historic names and business history,
see table at Railroads.

AT&SF	Atchison, Topeka & Santa Fe Ry
B&O	Baltimore & Ohio RR
C&EI	Chicago & Eastern Illinois RR
C&NW	Chicago & North Western Ry
C&O	Chesapeake & Ohio RR
CB&Q	Chicago, Burlington & Quincy RR
CA&E	Chicago, Aurora & Elgin RR
CGW	Chicago Great Western Ry
CMStP&P	Chicago, Milwaukee, St. Paul & Pacific RR
CNS&M	Chicago, North Shore & Milwaukee RR
CSS&SB	Chicago, South Shore & South Bend Ry
EJ&E	Elgin, Joliet & Eastern Ry
Erie	Erie RR
GM&O	Gulf, Mobile & Ohio RR
GTW	Grand Trunk Western Ry
IC	Illinois Central System
Monon	Chicago, Indianapolis and Louisville Ry (Monon Line)
NKP	New York, Chicago & St. Louis RR (Nickel Plate Road)
NYC	New York Central System
PRR	Pennsylvania Rail Road
Soo Line	Minneapolis, St. Paul & Sault Ste. Marie Ry
Wabash	Wabash RR

LAKE

MICHIGAN

- - - Built 1848–1855
—— Built 1856–1875
—— Built 1876–1895
— Built after 1895
......... Interurban railroads (all built after 1895)
▓ Built-up area circa 1955

Author: Michael P. Conzen

© 2004 The Newberry Library

Because of railroads, Chicago became the transportation center of the United States in the mid-19th century. At the height of its power in 1950, the city was home to thousands of miles of track that exchanged hundreds of freight cars every day. Chicago was served by 37 long-distance railroad lines that fanned out in all directions, connecting the Windy City with all corners of the nation. (Courtesy of the Newberry Library.)

In this view from 1925, brand-new McCormick-Deering all-steel threshers have just been loaded onto railroad cars. The machines were assembled at International Harvester's West Pullman Works on the South Side of Chicago. (Courtesy of the Wisconsin Historical Society, WHi-6801.)

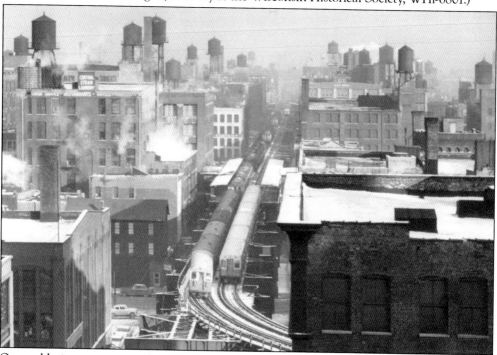

On a cold winter morning in January 1960, small factories and rooftop water tanks dominate the landscape on the Near North Side of Chicago. This view from the Merchandise Mart looking up Franklin Street shows numerous "L" (elevated) trains heading toward the Loop. The Grand Avenue Chicago Transit Authority (CTA) station is in the foreground. (Courtesy of the Krambles-Peterson Archive.)

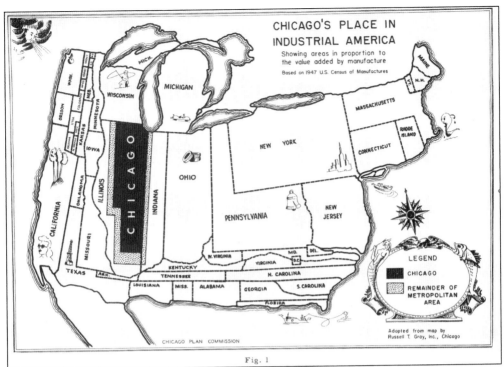

CHICAGO'S PLACE IN
INDUSTRIAL AMERICA

Showing areas in proportion to
the value added by manufacture

Based on 1947 U.S. Census of Manufactures

LEGEND

CHICAGO

REMAINDER OF
METROPOLITAN
AREA

Adapted from map by
Russell T. Gray, Inc., Chicago

CHICAGO PLAN COMMISSION

Fig. 1

When it comes to manufacturing diversity, it is hard to match Chicago. This stylized map from the early 1950s shows how the Windy City compared to the entire United States. If this map was re-created today, it would look much different, with many southern states being proportionately larger. (Courtesy of the Chicago History Museum, ICHi-037022.)

When this photograph was taken in the early 1900s, the Naperville Lounge Company was a small furniture manufacturer in a sleepy western suburb of Chicago. But, within several decades, Kroehler Manufacturing Company evolved into the world's largest producer of upholstered furniture. Strategic access to railroads enabled the factory to easily ship chairs, sofas, and other types of living room items. (Courtesy of the Naperville Heritage Society.)

This early 1950s magazine ad touts the Chicago area's manufacturing prowess. It promotes the Northern Illinois region as "the greatest industrial center of the United States." According to the ad, Chicago features many advantages, including being the railroad center of the United States, the geographical center of the United States, and the leader in iron and steel manufacturing.

New tractors await shipment in this 1935 view inside International Harvester's Tractor Works on the Southwest Side of Chicago. The models are McCormick-Deering T-40 TracTracTors, a crawler machine designed for use on rough terrain. (Courtesy of the Wisconsin Historical Society, WHi-12260.)

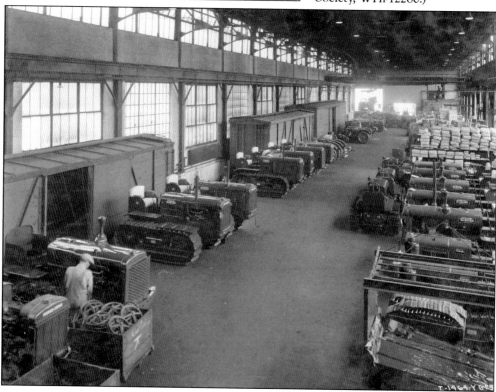

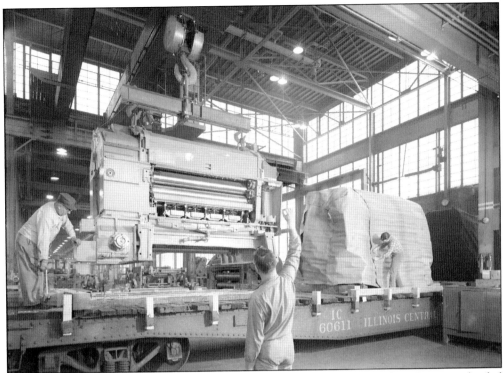

A large printing press, made by Miehle-Goss-Dexter, Inc., in west suburban Cicero, is loaded onto an Illinois Central flatcar for shipment. Once upon a time, scenes like this were common throughout the Chicago area. (Courtesy of the Chicago History Museum, HB-27229-B, Hedrich-Blessing Collection.)

During the late 19th century, the McCormick Works factory at Western and Blue Island Avenues took advantage of its proximity to rail and water transportation corridors that ran through the Southwest Side of Chicago. The large factory, which closed in 1961, was located along the Chicago Sanitary and Ship Canal. (Courtesy of the Wisconsin Historical Society, WHi-89192.)

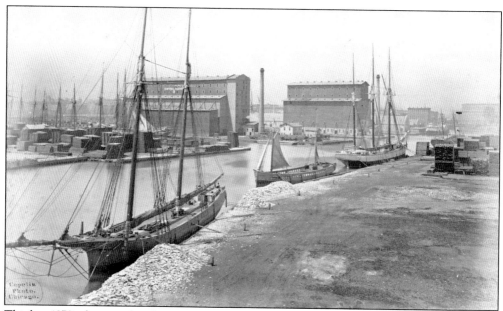

This late 1870s photograph, taken near the mouth of the Chicago River, shows numerous schooners, barges, and railroad cars lining the banks, which are overflowing with stacks of lumber. The vertical poles on the left side of the image are ship masts. The two large buildings are grain elevators. (Courtesy of the Chicago History Museum, ICHi-003145; Alexander J. Copelin, photographer.)

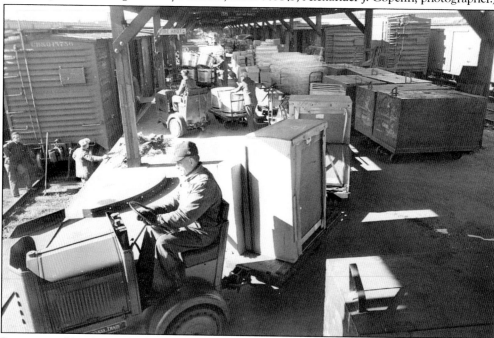

Busy scenes like this took place every day at Chicago's vast rail yards and freight houses. This photograph from the late 1940s shows the Milwaukee Road's Galewood Yard on the city's West Side. Some of the crates contain radio and television consoles assembled at the nearby Zenith Radio Corporation factories, which were strategically located beside this large rail yard. (Courtesy of the Chicago History Museum, ICHi-173842; Kaufmann & Fabry Co., photographer.)

Two

Early Manufacturing
in Chicago

When Chicago was founded in 1833, the city was a rough-and-tumble frontier outpost with fewer than 400 residents. Anything that resembled manufacturing activity was confined to one or two small blacksmith shops that produced crude iron objects on an as-needed basis.

The town lacked basic amenities, such as sewers, but it made up for it with location. Chicago's location at the southern tip of Lake Michigan made it easy to transport lumber by ship from the thick forests of Michigan and Wisconsin. The Windy City soon became the largest lumber distribution center in the world.

Because wood was readily available, it was an essential raw material for many early Chicago manufacturers. Lumber was turned into products, such as furniture, railroad cars, and wagons.

Shipbuilding also became an important industry in early Chicago. Two of the first ships built in the city were the *Clarissa* in 1836 and the *James Allen* in 1838. Four years later, James Averell established a shipyard near the Rush Street bridge, and by 1845, Chicago was producing eight schooners a year.

Chicago's abundant supply of lumber also appealed to agricultural equipment manufacturers, including Cyrus McCormick. He built a small factory on the banks of the Chicago River in 1847.

The two-story building included a 10-horsepower steam engine for driving machinery. Inside, carpenters made wooden frames, while other workers hammered, drilled, and riveted metal parts. During its first year in operation, the modest facility produced 450 machines and employed 33 men, including 10 blacksmiths.

Within two years, McCormick lengthened his factory from 100 to 190 feet, installed a 30-horsepower steam engine, and added a rail spur. Soon, more than 200 employees were turning out 40 machines per day, and the factory occupied more than 100,000 square feet of floor space.

One of McCormick's greatest contributions to the growth of Chicago manufacturing is that he purchased some parts from a network of local suppliers that operated small forges and machine shops. For instance, a local businessman named Thomas Sherry provided many of the metal castings and cast-iron parts that were needed to make early reapers.

The success of McCormick's operation also attracted other farm implement manufacturers to the city, including George Easterly, who built a factory to make a grain header, and William Deering, who eventually set up a huge reaper works of his own elsewhere along the Chicago River.

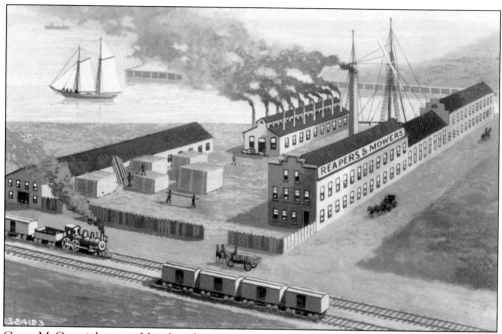

Cyrus McCormick opened his first factory in Chicago in 1847. The McCormick Reaper and Mower Works was located on the north bank of the Chicago River, just east of today's Michigan Avenue bridge. The building was 100 feet long by 30 feet wide and employed 33 men. (Courtesy of the Wisconsin Historical Society, WHi-8184.)

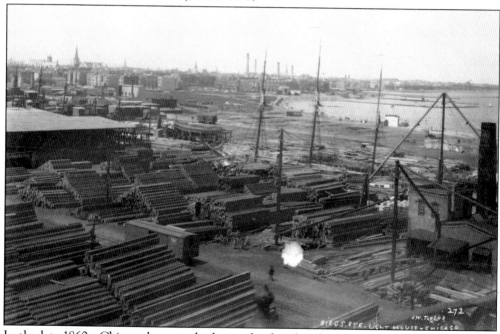

In the late 1860s, Chicago became the largest lumber distribution center in the world. Every day, ships loaded with wood from forests in Michigan and Wisconsin arrived in the city. This photograph shows stacks of lumber sitting on the lakefront. (Courtesy of the Chicago History Museum, ICHi-029531; J.W. Taylor, photographer.)

This ad from the early 1850s touts the technical expertise of H.H. Scoville & Sons, which was located at the corner of Adams and Canal. The company made rolling stock for the first railroad to operate in the Windy City, the Galena & Chicago Union. Hiram Scoville also started the Chicago Locomotive Works, which produced its first machine in 1853.

Machines mass-produced by the McCormick Reaper and Mower Works dramatically improved productivity on farms around the world. Growing demand for mechanical reapers and other types of horse-drawn farm implements made Chicago a manufacturing powerhouse in the 19th century. (Courtesy of the Wisconsin Historical Society, WHi-39504.)

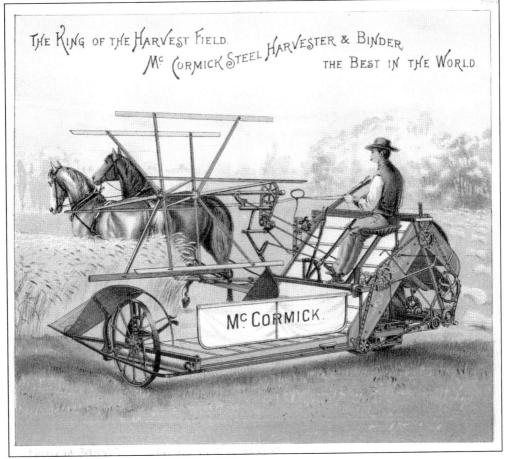

THE KING OF THE HARVEST FIELD. McCORMICK STEEL HARVESTER & BINDER. THE BEST IN THE WORLD.

McCORMICK.

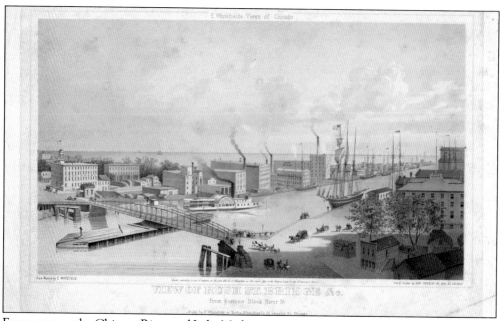

Easy access to the Chicago River and Lake Michigan was important to early manufacturers. This 1861 lithograph shows the area east of the Rush Street swing bridge. Several structures lining the north side of the river in the middle of this scene comprise the McCormick Reaper Works. Unfortunately, most of the buildings in this part of the city were destroyed 10 years later in the Great Chicago Fire. (Courtesy of the Wisconsin Historical Society, WHi-74587.)

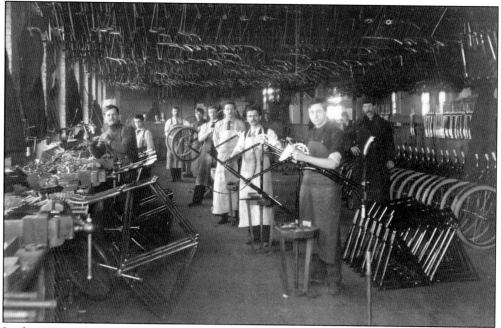

In the 1890s, Chicago became the bicycle manufacturing capital of the world. More than 30 companies were located along a stretch of Lake Street in an area that was known as "bicycle row." Chicago continued to dominate the bike industry through most of the 20th century because of manufacturers such as Arnold, Schwinn & Company. (Courtesy of Mark Mattei.)

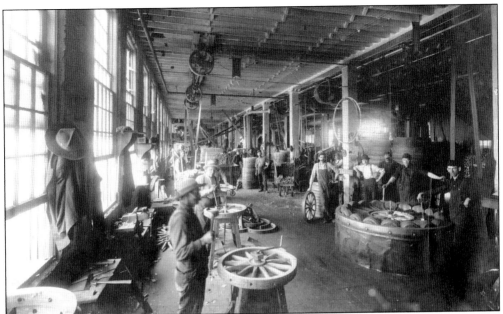

Because of the abundant supply of lumber, Chicago attracted companies that mass-produced carriages and wagons. One of the largest manufacturers in the country was the Weber Wagon Works, which was founded in 1845 by a German immigrant. The company eventually was absorbed into the International Harvester Company. (Courtesy of the Wisconsin Historical Society, WHi-7690.)

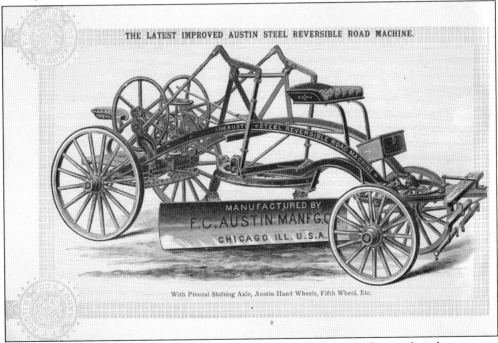

The F.C. Austin Manufacturing Company was founded in 1849 to make farm tools and equipment. It eventually specialized in horse-drawn scrapers that were used to build railroads and maintain dirt roads. (Courtesy of the Chicago Public Library, Special Collections, Trade Catalog Collection.)

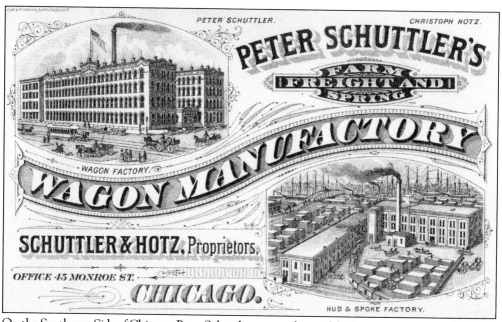

On the Southwest Side of Chicago, Peter Schuttler operated one of the largest wagon manufacturing plants in the United States. By the late 1870s, the factory was consuming four million feet of lumber and 20,000 tons of iron per year. (Courtesy of the Chicago History Museum, ICHi-173843.)

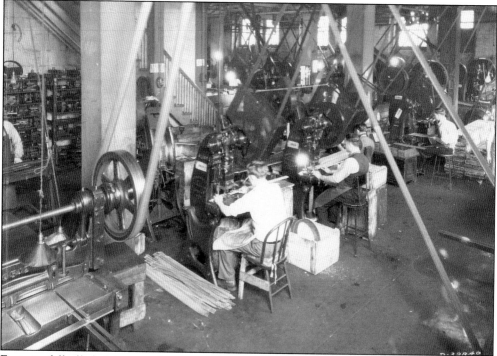

Factories full of belt-driven machinery were a common sight in 19th-century Chicago. In the days before electric motors, machines were powered by steam engines that turned ceiling-mounted lines and shafts. Drills, lathes, punch presses, and other types of production equipment were attached to leather drive belts. (Courtesy of the Wisconsin Historical Society, WHi-28527.)

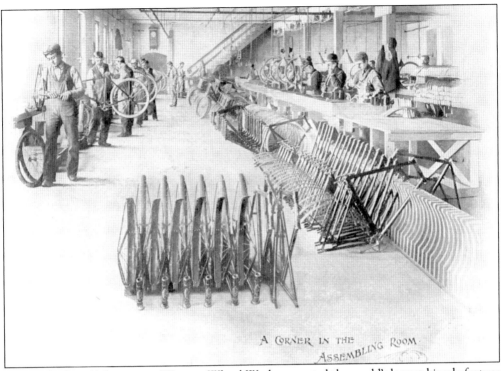

During the late 19th century, Western Wheel Works operated the world's largest bicycle factory on the Near North Side of Chicago. The company pioneered mass-production techniques such as sheet metal stamping and electric resistance welding. (Courtesy of the Chicago Public Library, Special Collections, Trade Catalog Collection.)

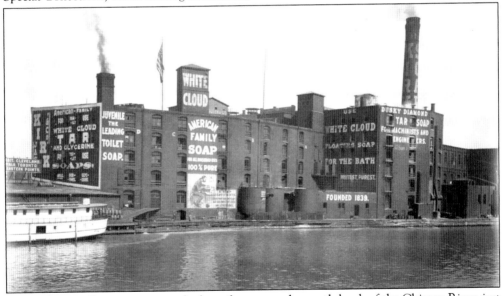

The Kirk Soap Company operated a large factory on the north bank of the Chicago River, just east of the Michigan Avenue bridge. In the late 1920s, the company built a new plant along the north branch of the Chicago River near North Avenue that was eventually acquired by Procter & Gamble. (Courtesy of the Chicago History Museum, ICHi-093181.)

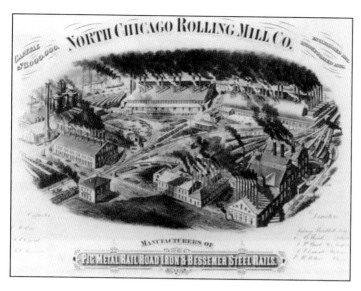

The North Chicago Rolling Mill Company, at 1319 Wabansia Avenue on the west bank of the Chicago River, was founded in 1857. Within three years, it was producing 100 tons of iron rails daily. On May 24, 1865, the company produced the first high-strength steel rails in America, enabling railroads to increase the size and weight of their steam locomotives. (Courtesy of the Joliet Area Historical Museum.)

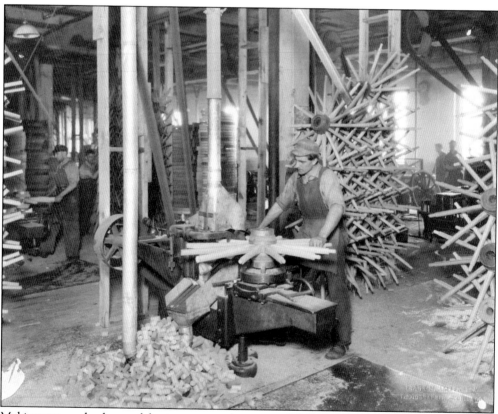

Making wagon wheels was a laborious process that required skilled craftsmen, who were often recent European immigrants. This scene depicts activity inside the Weber Wagon Works in Auburn Park on the South Side of Chicago. (Courtesy of the Wisconsin Historical Society, WHi-45714.)

Between 1878 and 1900, the Gormully & Jeffery Manufacturing Company was one of the largest bicycle producers in America. Various steps in the assembly process are shown in this late-1880s illustration that depicts life inside the factory, located at 222–228 North Franklin Street. In 1902, Thomas Jeffery became an early pioneer in the US auto industry when he began making Rambler runabouts at a factory 50 miles north of Chicago in Kenosha, Wisconsin.

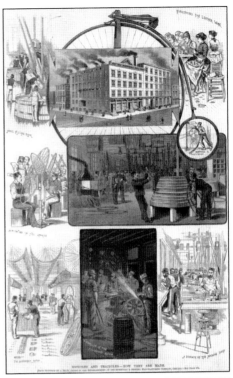

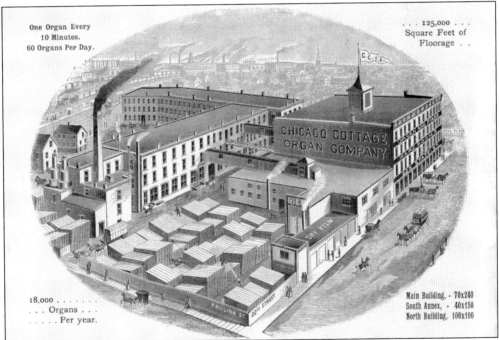

By using state-of-the-art machinery, the Chicago Cottage Organ Company boasted that it produced "one organ every 10 minutes; 60 organs per day." The factory was located at the corner of Twenty-Second (Cermak Road) and Paulina Streets. Stacks of lumber in the foreground are waiting to be processed. (Courtesy of the Chicago History Museum, ICHi-173841.)

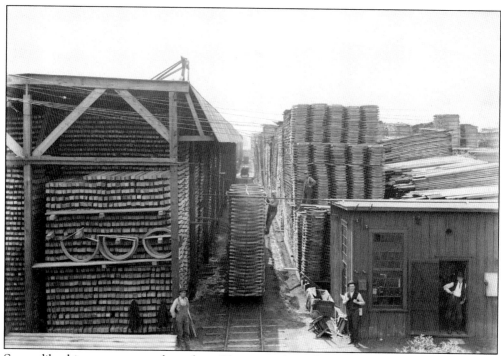

Scenes like this were common throughout Chicago in the 19th century. Many manufacturers had piles of wood surrounding their factories. The Windy City's abundant supply of lumber attracted companies that made agricultural equipment, furniture, pianos, railroad cars, ships, and wagons. (Courtesy of the Wisconsin Historical Society, WHi-7686.)

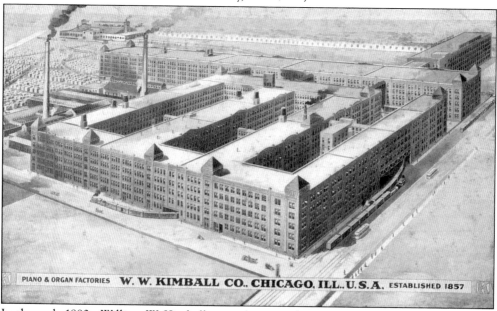

PIANO & ORGAN FACTORIES W. W. KIMBALL CO., CHICAGO, ILL., U.S.A., ESTABLISHED 1857

In the early 1880s, William W. Kimball opened a piano factory at Twenty-Sixth and Rockwell Streets. Within 30 years, he employed 1,500 people and produced more than 13,000 pianos a year. During the 1950s, the factory moved to west suburban Melrose Park. (Courtesy of the Chicago Public Library, Special Collections, Trade Catalog Collection.)

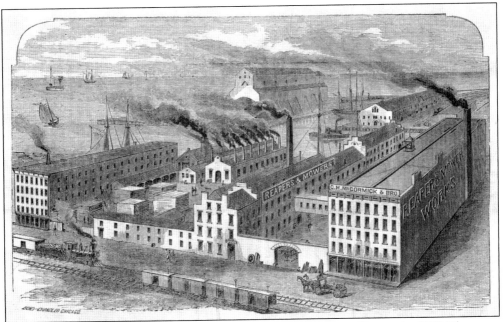

The McCormick Reaper & Mower Works was the largest factory in Chicago by 1868. That year, the facility turned out more than 9,500 machines. However, the factory was destroyed in the 1871 Great Chicago Fire. (Courtesy of the Wisconsin Historical Society, WHi-64060.)

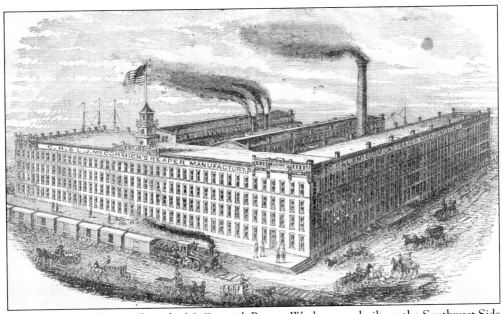

After the Great Chicago Fire, the McCormick Reaper Works was rebuilt on the Southwest Side of the city. The factory quickly expanded and soon became one of the largest manufacturing complexes in the world. (Courtesy of the Wisconsin Historical Society, WHi-24887.)

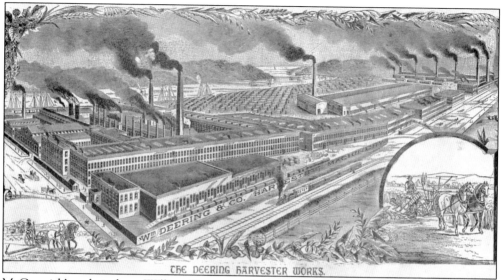

THE DEERING HARVESTER WORKS.

McCormick's archrival was William Deering and Company (the two firms eventually merged in 1901 to form International Harvester). Deering built horse-drawn grain binders and mowers at a large complex located on the north branch of the Chicago River, bounded by Clybourn and Fullerton Avenues. This 1888 engraving shows the immense size of the Deering Harvester Works. (Courtesy of the Wisconsin Historical Society, WHi-39526.)

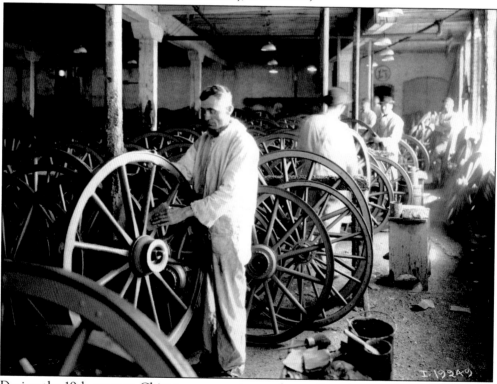

During the 19th century, Chicago was a major producer of carriages and wagons. Leading manufacturers included Peter Schuttler, Staver & Abbott, and Weber Wagon Works. (Courtesy of the Wisconsin Historical Society, WHi-7698.)

In the late 1880s, the F.C. Austin Manufacturing Company became the largest producer of construction equipment in the United States. It specialized in concrete mixers, scrapers, steam rollers, sweepers, and other types of street maintenance equipment. (Courtesy of the Joliet Area Historical Museum.)

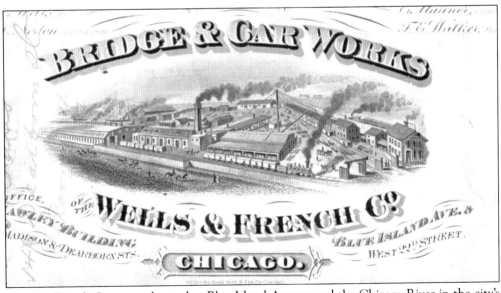

Wells & French Company, located at Blue Island Avenue and the Chicago River in the city's lumber district, was one of several railroad car manufacturers established in Chicago during the mid-19th century. Other major producers were the American Car Company, the Eagle Works of P.W. Gates & Company, and the Union Car & Bridge Works.

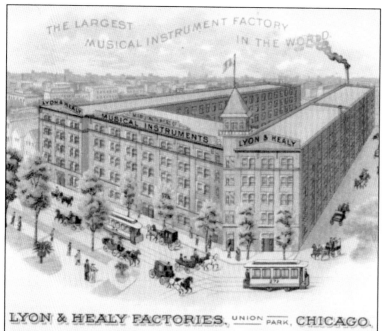

Lyon & Healy was founded in Chicago in 1864 and quickly became one of the world's largest manufacturers of musical instruments. It operated a large factory that produced harps, pianos, and other products on the Near West Side at the intersection of Randolph and Ogden. (Courtesy of Lyon & Healy Harps, Inc., Chicago.)

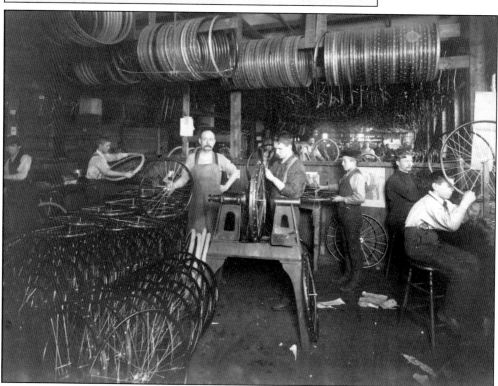

A young German bicycle maker named Ignaz Schwinn immigrated to America in the early 1890s and settled in Chicago. In 1895, he went into business with local meatpacker Adolph Arnold. They opened a factory at the northwest corner of Lake and Peoria Streets on the Near West Side of Chicago. (Courtesy of Mark Mattei.)

Many companies that supplied the railroad industry had factories in Chicago. For example, Adams & Westlake was a prominent manufacturer of hardware, lamps, lanterns, and signaling equipment. The company started in Chicago in 1857 and later operated this factory at 319 West Ontario Street in the River North area. The building on the right belonged to M.J. Holloway and Company, a candy company famous for treats such as Milk Duds and Slo Pokes. (Courtesy of the University of Illinois at Chicago Library.)

This illustration from the early 1880s shows production activity inside the McCormick Reaper Works on the Southwest Side of Chicago. At the time, workers were still using basic hand tools to produce parts and subassemblies. However, the factory became more mechanized as production volumes steadily increased in the late 1880s.

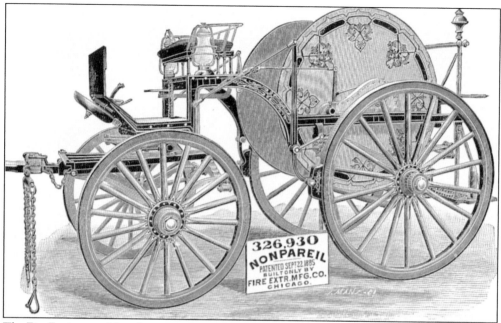

The Fire Equipment Manufacturing Company on South Des Plaines Street was a leading producer of hand- and horse-drawn fire engines. Its equipment was used by fire departments around the United States. Ironically, the company was located just a few blocks north of where the Great Chicago Fire started in 1871. (Courtesy of the Chicago Public Library, Special Collections, Trade Catalog Collection.)

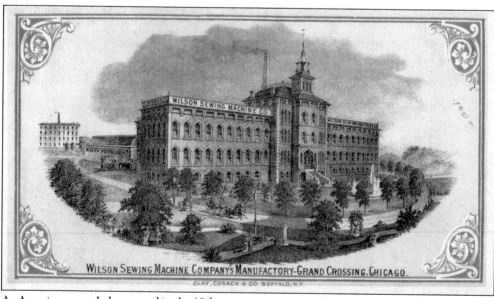

As America expanded westward in the 19th century, many manufacturers relocated their operations to the fast-growing city of Chicago. A good example was the Wilson Sewing Machine Company. In the mid-1870s, it moved its factory from Cleveland to the Grand Crossing neighborhood on the South Side of Chicago. (Courtesy of the Chicago Public Library, Special Collections, Trade Catalog Collection.)

Three

THAT WAS MADE
IN CHICAGO?

Chicago reached the height of its manufacturing power in the late 1940s. The post–World War II economy was booming and factories were struggling to keep up with pent-up consumer demand. Classified pages of local newspapers were full of help wanted ads from companies that operated factories in all corners of the city.

For instance, in one 1947 issue of the *Chicago Tribune*, Bodine Electric (electric motors) needed first-shift drill press operators, Chicago Coin Machine (arcade games) wanted solderers, and Danly Machine Specialties (metalworking equipment) was looking for electrical assemblers. Dole Valve (beverage dispensing equipment) needed a development engineer, Irving Shoe (women's footwear) wanted a cutting foreman, and Monroe Stove (cooking appliances) was looking for spot welders. Rembrandt Lamp (light fixtures) needed polishers and buffers, Revere Camera (home movie cameras and projectors) wanted draftsmen, and Wilson Jones (office products) was looking for punch press operators.

The list went on and on. In fact, it is hard to name a product that was not made in the Windy City and its environs at one point or another.

A good example is automobiles and trucks. During the first decade of the 20th century, 28 companies produced 68 models of cars in Chicagoland.

Often, one industry morphed into another. Chicago was a major producer of bicycles, carriages, and wagons in the late 19th century. When automobiles first started to appear, many of those manufacturers began tinkering with horseless carriages and motorcars. In fact, between 1895 and 1900, more than 20 local companies were formed.

Chicago became a leading producer of electric automobiles thanks to the efforts of manufacturers like American Electric Vehicle, Borland-Grannis, Chicago Electric Motor Company, Crowdus Automobile Company, and C.P. Kimball & Company. The Woods Motor Vehicle Company alone built more than 13,000 vehicles between 1896 and 1918.

By the early 1920s, more than 20 companies were building trucks and commercial vehicles in Chicago. And the city was home to more than 600 firms making a wide variety of auto parts, such as axles, carburetors, gears, lamps, and radiators.

A similar evolutionary pattern occurred with other manufacturers and industries in Chicago. For instance, the city excelled at producing radios, televisions, mechanical musical instruments, and coin-operated novelty machines. All of those products had one thing in common—they featured finely crafted wood cabinets. The expertise needed to produce them was honed by a long tradition of furniture manufacturing in Chicago.

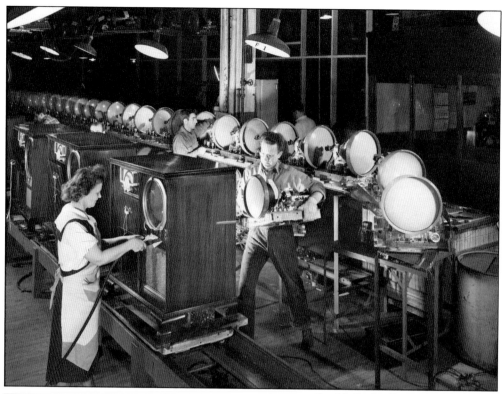

Zenith Radio Corporation's largest factory was located on West Dickens Avenue on the West Side of Chicago. In this photograph from 1950, assemblers are building combination television-radio-phonograph consoles. The device was housed in an elaborate wood cabinet that resembled a piece of fine furniture. (Courtesy of the Chicago History Museum, ICHi-022216; Sarra, Inc., photographer.)

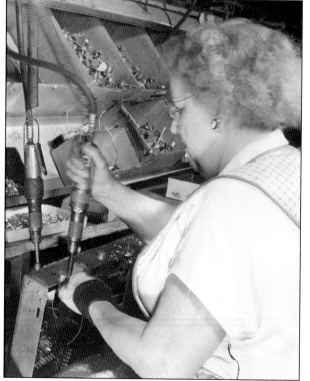

"The quality goes in before the name goes on" was Zenith's famous slogan for decades. This woman is using an air-driven screwdriver to assemble a metal tray that holds electronic control components. (Courtesy of the Chicago History Museum, ICHi-173770.)

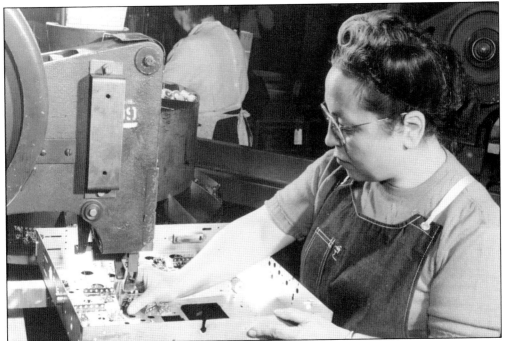

For decades, the Zenith Radio Corporation factories in Chicago were a beehive of activity that employed more than 6,000 people. In this 1952 photograph, a woman is riveting the steel chassis of an early television set. (Courtesy of the Chicago History Museum, ICHi-173771.)

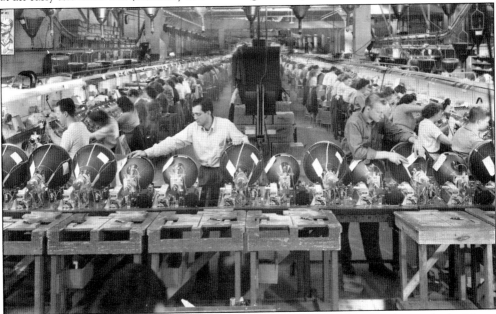

In the late 1940s and early 1950s, Chicago was the world's leading producer of televisions. Companies such as Admiral and Zenith relied on many smaller manufacturers for picture tubes, metal stampings, and other parts. Many of the components along the assembly line in this photograph are from local suppliers. (Courtesy of the Chicago History Museum, ICHi-003234; Sarra, Inc., photographer.)

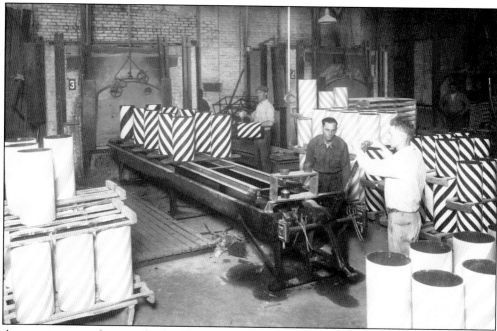

At one time, nearly every barbershop in America used equipment produced by the Emil J. Paidar Company on the North Side of Chicago. Barber chairs, barber poles, and other items were made at the company's factory on North Wells Street. (Courtesy of the Chicago History Museum, ICHi-039368.)

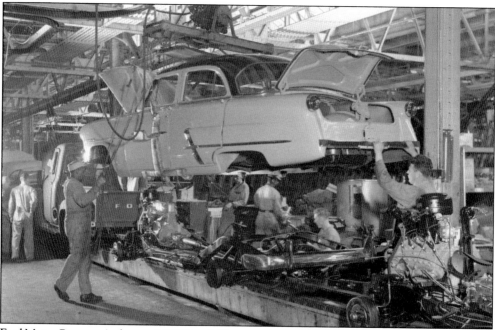

Ford Motor Company's plant at 12600 South Torrence Avenue is the automaker's oldest continuously operating factory. This photograph from 1953 shows Crestline sedans and F-100 pickup trucks on the assembly line. Today, the 95-year-old plant in the Hegewisch neighborhood on Chicago's Southeast Side is the largest factory in the city. (Courtesy of the Ford Motor Company.)

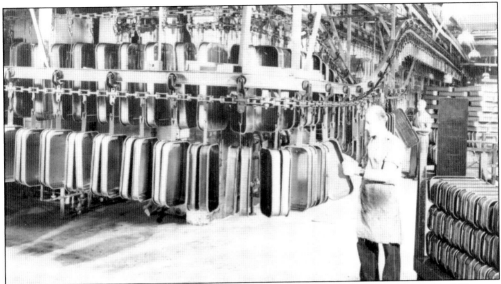

The Liberty Coaster Manufacturing Company was founded in 1917 on the West Side of Chicago by Italian immigrant Antonio Pasin. His company soon became the world's largest producer of coaster wagons, scooters, and other types of children's ride-on toys. During the 1930s, the renamed Radio Steel and Manufacturing Company began using metal stamping technology to mass-produce its popular Radio Flyer "little red wagon." (Courtesy of Radio Flyer, Inc.)

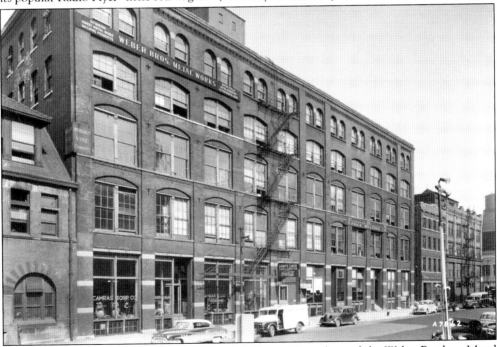

The upper floors of this building at 100 North Jefferson Street housed the Weber Brothers Metal Works Company. In the early 1950s, an employee named George Stephen cut a steel buoy in half and created a barbecue for his backyard. Today, Weber-Stephen Products is a top manufacturer of outdoor grilling equipment and operates a factory in the northwest suburbs of Chicago. (Courtesy of the University of Illinois at Chicago Library.)

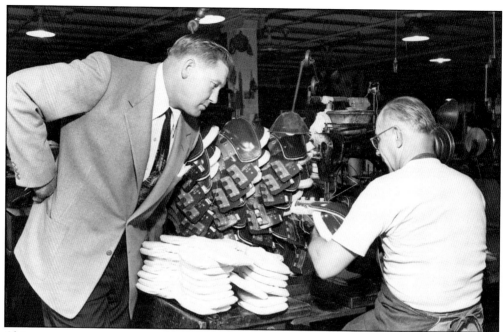

Chicago once was a major producer of sporting goods. This publicity photograph shows Clyde "Bulldog" Turner, an all-star center for the Chicago Bears football team in the 1940s, visiting the Wilson Sporting Goods factory. He is posing with an employee who is sewing pieces of rubber into knee and shoulder pads. (Courtesy of the Chicago History Museum, ICHi-173781.)

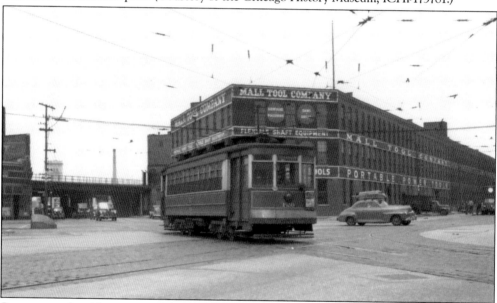

Streetcars and tool factories once dominated the Chicago landscape. In this June 1946 photograph, a Chicago Surface Lines car eastbound on Seventy-Ninth Street passes the Mall Tool Company, an important manufacturer of benchtop grinders, chain saws, circular saws, drills, and other types of portable power tools. The factory was located on South Chicago Avenue. The streetcar was built a few miles away at the Pullman plant. (Courtesy of the Krambles-Peterson Archive; J.L. Diaz, photographer.)

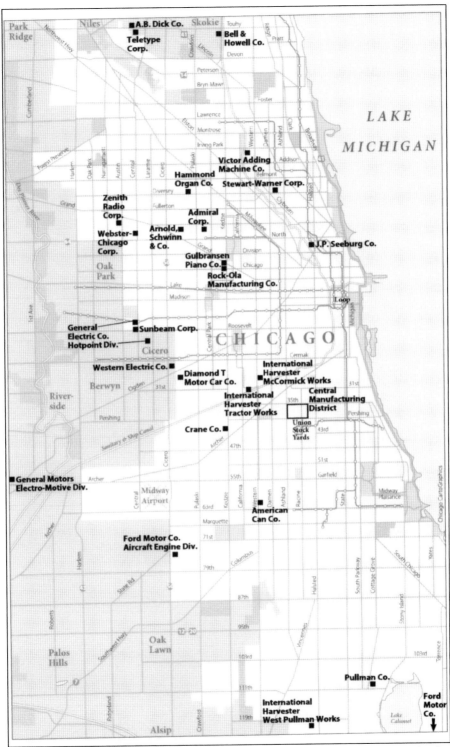

During the 1950s, Chicago was home to many notable factories that employed thousands of people. This map shows the location of a few of the largest facilities in the city and nearby suburbs.

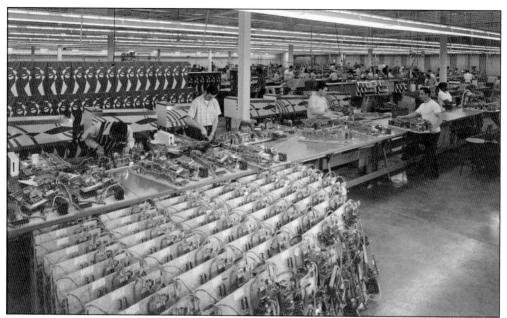

Chicago was once the world's leading manufacturer of coin-operated novelty games. This early-1970s photograph shows wiring harnesses waiting to be installed in pinball machines at Gottlieb and Company in west suburban Northlake. (Courtesy of A. Epstein and Sons, Inc.)

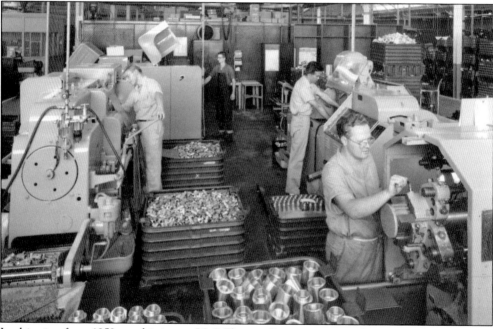

In this view from 1959, machinists at S&C Electric Company are producing metal components that will be used in switch gear and other types of high-voltage electrical distribution equipment. The company has been a major provider of equipment used for switching, protecting, and controlling electric power systems since 1911. Today, its manufacturing campus still occupies several blocks along Ridge Boulevard in Chicago's Rogers Park neighborhood. (Courtesy of S&C Electric Company.)

For many years, the term "Genuine Johnsons" was synonymous with ice skates. The Nestor Johnson Manufacturing Company operated a factory at 1900 North Springfield Avenue. The Chicago-made products were popular with champion figure skaters, hockey players, and speed skaters.

Between 1923 and 1970, the Henry C. Grebe Company operated a seven-acre shipyard on the North Side of Chicago that specialized in building custom yachts for wealthy customers located throughout the United States. Skilled wood craftsmen also made all the cabin furniture and interior components in-house. (Courtesy of the Chicago Maritime Society.)

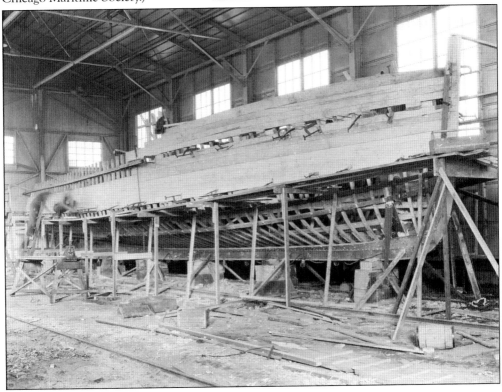

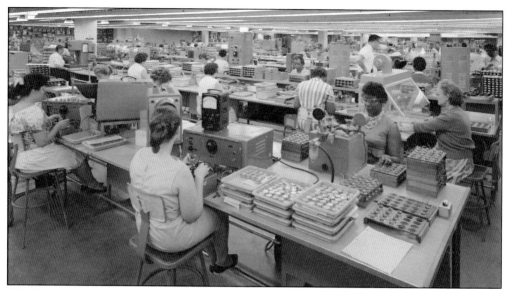

The Shure Company began manufacturing microphones in Chicago in the early 1930s. By the late 1940s, it had also become one of the world's largest producers of phonograph cartridges. This photograph from 1962 shows microphones being assembled at the Shure factory in north suburban Evanston. (Courtesy of the Chicago History Museum, HB-25733-B, Hedrich-Blessing Collection.)

Chicago has been a top producer of cardboard boxes and packaging materials for decades. This photograph from the late 1940s shows a worker at Container Corporation of America producing corrugated shipping cartons for Philadelphia Cream Cheese, a popular brand owned by Kraft, a leading food manufacturer that is still based in Chicagoland. (Courtesy of the Chicago History Museum, ICHi-173820.)

For most of the 20th century, the Bell & Howell Company was a foremost manufacturer of motion picture cameras and projectors based on the North Side of Chicago. It claimed to be "the largest manufacturer of professional motion picture equipment for Hollywood and the world."

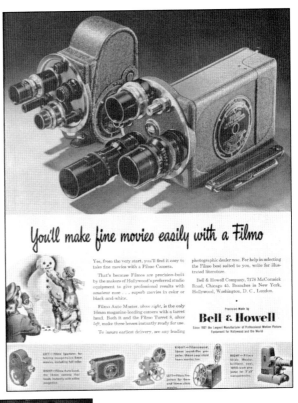

At one time, Bell & Howell products could be found in nearly every school in America. In this photograph, a quality inspector is examining a new batch of 16-millimeter Filmosound projectors in the foreground, while assemblers work in the background. (Courtesy of the Chicago History Museum, HB-14857-A, Hedrich-Blessing Collection.)

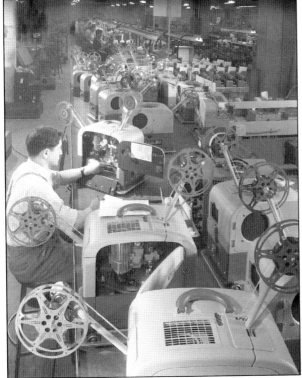

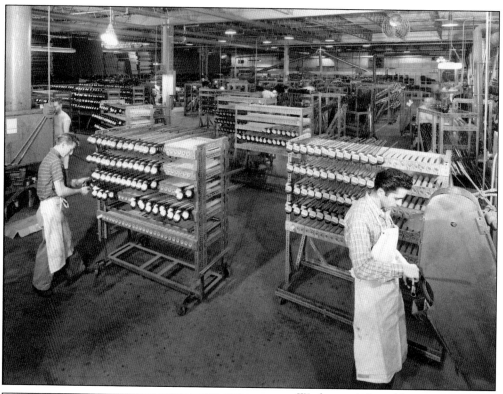

Workers polish and lacquer wood golf clubs at the Sportsman's Golf Corporation factory, located at 2020 Indian Boundary Road in west suburban Melrose Park. The company started in a small tool-and-die shop on the West Side of Chicago in the late 1940s and produced clubs under brand names such as Bristol and Kroydon. In 1967, the company changed its name to Ram Golf. (Courtesy of the Chicago History Museum, ICHi-173777; Harold S. Beach, photographer.)

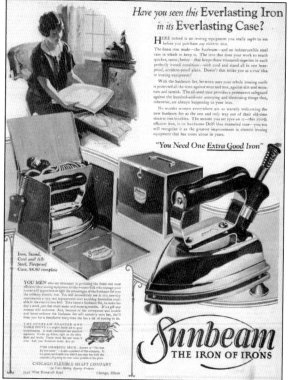

The Chicago Flexible Shaft Company was a leading manufacturer of small electrical appliances. It produced hair trimmers, irons, mixers, toasters, and other products on the West Side of Chicago. Its Sunbeam brand became so well known that it was eventually adopted as the name of the company in 1946.

In the early 1950s, Ford Motor Company acquired the former Dodge-Chicago plant on the Southwest Side of Chicago and began assembling engines for Cold War–era military fighter jets. This photograph from 1954 shows a front compressor assembly being lowered into a J57 turbojet engine. The site of this factory eventually became the Ford City Shopping Center in 1965.

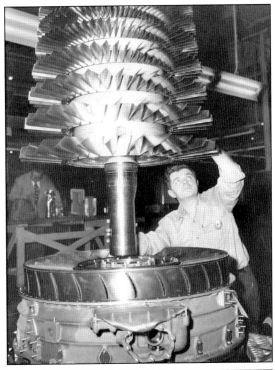

One of the most popular exhibits at the 1933 Century of Progress International Exposition on Chicago's lakefront was the General Motors pavilion. It featured a working assembly line. The unique attraction produced Chevrolet Master Eagle four-door sedans, which could be purchased on-site. (Courtesy of General Motors LLC.)

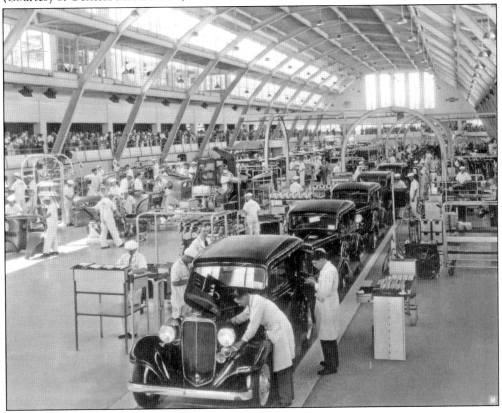

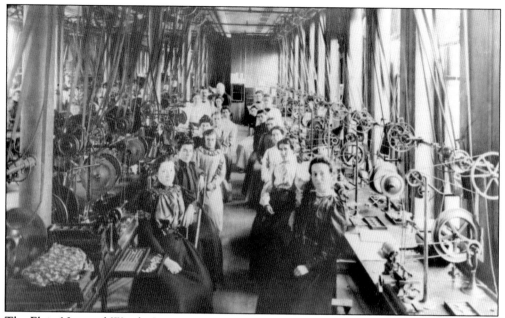

The Elgin National Watch Company operated from 1864 to 1968. This photograph from the 1890s shows the gilding room at the company's large factory on the east bank of the Fox River in northwest suburban Elgin. Female employees had to be careful that their loose-fitting clothes and long hair did not become entangled in the unguarded machinery. (Courtesy of the Elgin History Museum.)

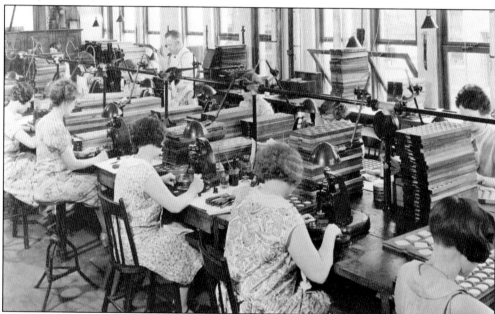

By the time this photograph was taken in the late 1920s, hairstyles, fashions, and working conditions at Elgin Watch had changed dramatically. At the time, the company produced more than half the watches sold in America. After the market changed dramatically, the historic factory was closed in 1965. (Courtesy of the Chicago History Museum, ICHi-020399; Elmer Gylleck, photographer.)

Monark Silver King, Inc., made bicycles and lawn mowers on the West Side of Chicago. The company's popular line of bikes featured Art Deco styling, aluminum frames, stainless-steel fenders, and balloon tires. This ad depicts the company's product line in the early 1950s.

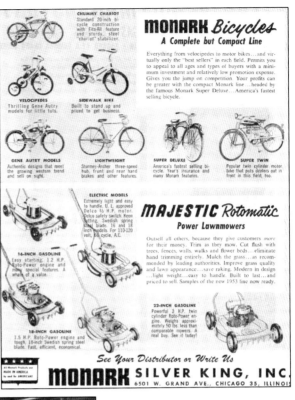

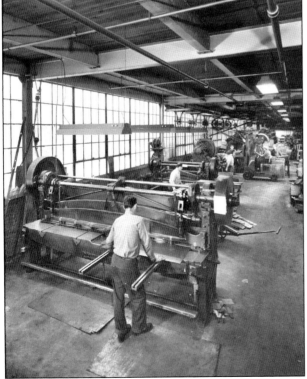

Machine shops like this were the backbone of Chicago manufacturing, supplying the numerous metal parts needed to assemble many types of products. In this photograph from the early 1950s, large windows provide natural light as workers use planers to cut sheets of steel. The equipment in the background is still driven by old-fashioned overhead line shafts and belts. (Courtesy of the Chicago History Museum, ICHi-173815.)

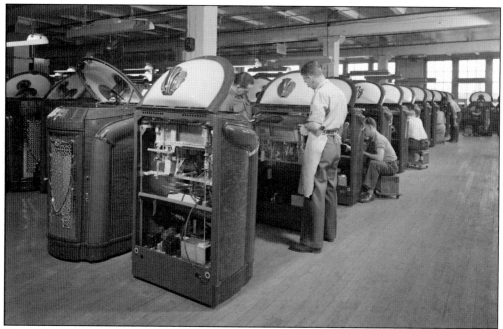

Back when nearly everyone in America listened to music on jukeboxes, many of the machines were made in Chicago. One of the primary manufacturers was the J.P. Seeburg Corporation. It operated a large factory at 1500 North Dayton Street. (Courtesy of the Chicago History Museum, HB-10083-I, Hedrich-Blessing Collection.)

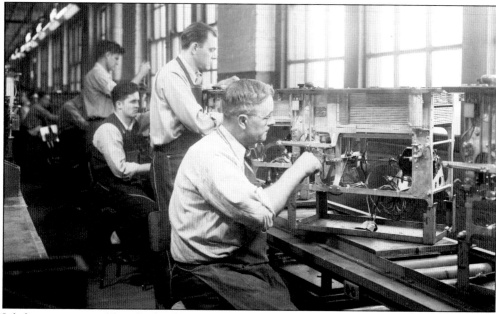

Jukeboxes contained hundreds of mechanical components, hidden behind decorative wooden cabinets. In this 1947 photograph, assemblers at the J.P. Seeburg factory on the North Side of Chicago prepare cams, gears, record changers, and other complex mechanisms that will enable people to play coin-operated music. (Courtesy of the Chicago History Museum, HB-10083-C, Hedrich-Blessing Collection.)

Webster-Chicago Corporation was a leading manufacturer of electronic equipment such as wire recorders, which were popular in the days before magnetic plastic audio tape. In this photograph, the Model 288 wire recorder is being assembled at the company's factory on Bloomingdale Avenue in the North Austin neighborhood. (Courtesy of the Chicago History Museum, ICHi-173813.)

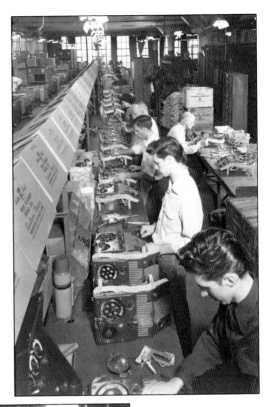

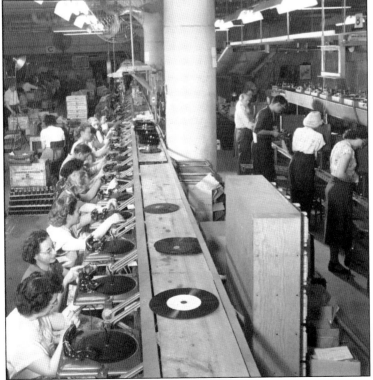

Webster-Chicago also produced automatic record changers. This photograph with a view looking up the assembly line shows machines in the foreground that are about to be tested. (Courtesy of the Chicago History Museum, ICHi-173814.)

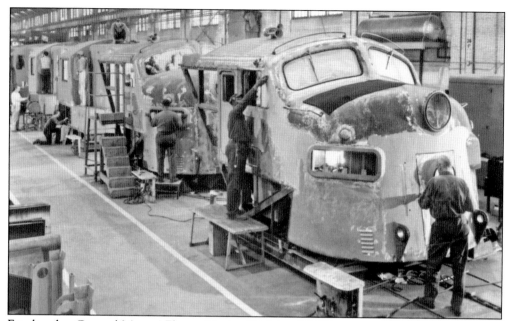

For decades, General Motors' Electro-Motive Division (EMD) in west suburban McCook was the world's largest manufacturer of diesel locomotives. The automaker adopted mass-production techniques, such as moving assembly lines, to improve productivity at the plant. By the time this photograph was taken in the late 1950s, more than 50 percent of all diesel locomotives in use were made by EMD. (Courtesy of General Motors LLC.)

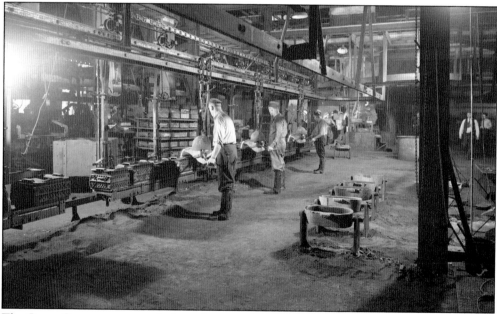

The Crane Company operated a large factory on the Southwest Side of Chicago that produced valves, fittings, and other types of plumbing fixtures. A key part of the 47-building "Great Works" operation was the foundry, which could produce 800 tons of forgings a day. This 1940s photograph shows workers pouring castings that were transported via an overhead conveyor system. (Courtesy of the Chicago History Museum, HB-07643-F2, Hedrich-Blessing Collection.)

Monogram Models, Inc., was a leading producer of plastic kits and slot cars. This ad from 1964 shows part of the company's diverse line of models that were produced at 8601 Waukegan Road in north suburban Morton Grove.

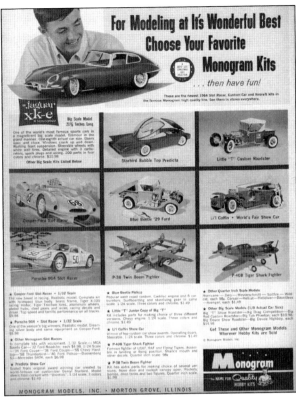

The Bates Aeroplane Company operated a factory in Chicago from 1907 to 1912. Ray Harroun, winner of the first Indianapolis 500 motor race in 1911, was an investor in the firm. Bates was acquired by the Heath Aircraft Company, another local aviation pioneer, that was located at 1721–1729 Sedgwick Street. (Courtesy of the Wisconsin Historical Society, WHi-11765.)

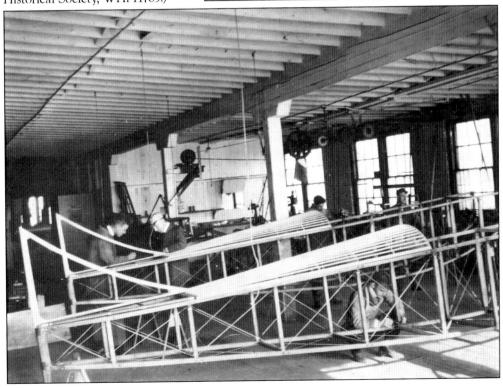

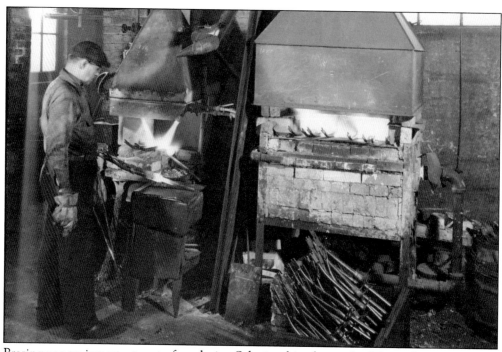

Brazing was an important part of producing Schwinn bicycles on the West Side of Chicago. It enabled factory workers to join together the chrome molybdenum steel tubing that was used to make sturdy, lightweight frames. (Courtesy of Mark Mattei.)

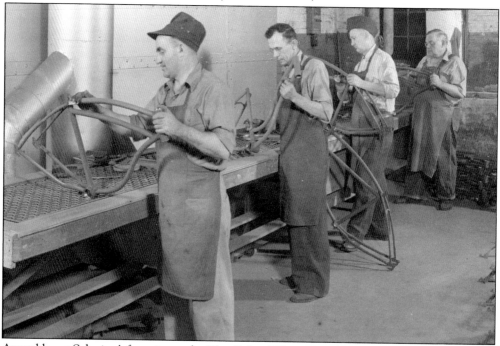

Assemblers at Schwinn's factories on the West Side of Chicago perfected the art of welding tubular steel. That attention to quality helped the company become the world's chief bike manufacturer. (Courtesy of Mark Mattei.)

During the 1960s and 1970s, Schwinn's Chicago factories mass-produced a variety of popular bikes, with brand names such as Continental, Orange Krate, Paramount, Sting-Ray, Typhoon, and Varsity. The company produced one million bikes in 1968. However, the last Chicago-built Schwinn was made in 1982. (Courtesy of Mark Mattei.)

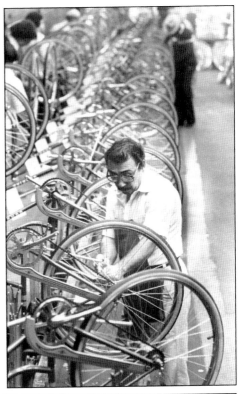

In 1950, one in every four bicycles sold in the United States was a Schwinn. The Chicago-based company enjoyed an unrivaled reputation for innovative design, quality manufacturing, and loyal customers. This photograph shows Schwinn engineers hard at work designing new products. One of the calendars on the wall is from a local supplier called Chicago Gear Manufacturing Company. (Courtesy of Mark Mattei.)

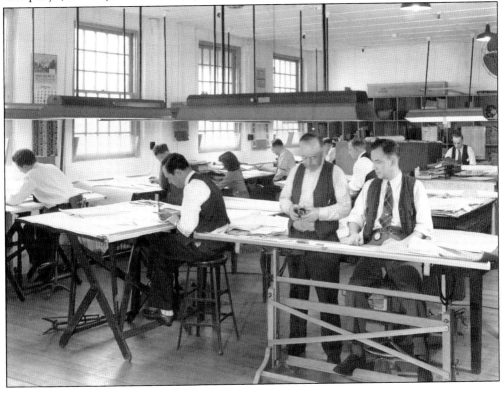

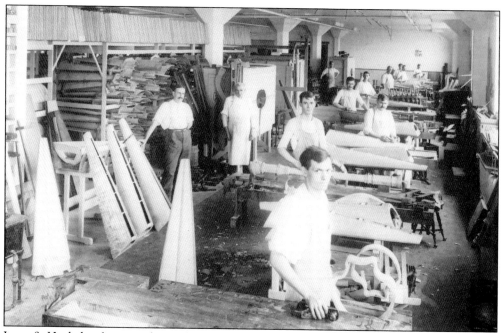

Lyon & Healy has been producing harps on the Near West Side of Chicago since 1890, which was around the era when this photograph was taken. The company also used to make other types of wooden musical instruments, such as drums, guitars, and pianos. (Courtesy of Lyon & Healy Harps, Inc., Chicago.)

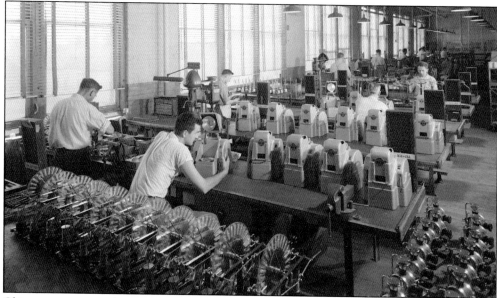

Chicago was once a foremost producer of scientific instruments and laboratory apparatus and supplies, such as centrifuges, microscopes, scales, and anatomical models. Top manufacturers included Central Scientific, Denoyer-Geppert, E.H. Sargent, and W.M. Welch Scientific. This view from the early 1950s shows the assembly line at Central Scientific, which was located at 1700 West Irving Park Road. (Courtesy of the Chicago History Museum, HB-15203-F, Hedrich-Blessing Collection.)

Chicago was ground zero for the early electronics industry. As this ad from the mid-1940s explains, Galvin Manufacturing Company was one of the companies at the forefront of this new technology. In 1947, the company changed its named to Motorola, which was a popular brand of radios.

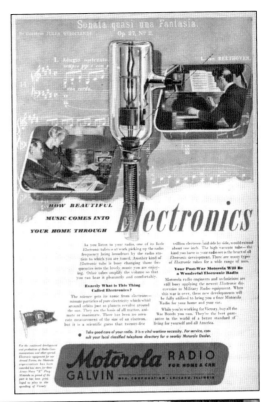

In the days before federal safety laws were enacted, factories often posed many potential hazards for workers. This photograph shows the pickling department (part of an enameling process) at the American Stove Company plant in south suburban Harvey. The worker is lowering a batch of parts into an open vat of sulfuric acid. (Courtesy of the Chicago History Museum, HB-07480-D, Hedrich-Blessing Collection.)

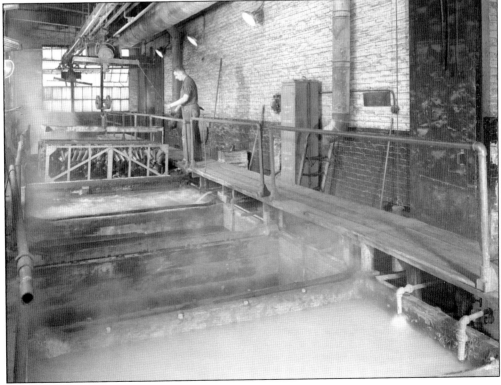

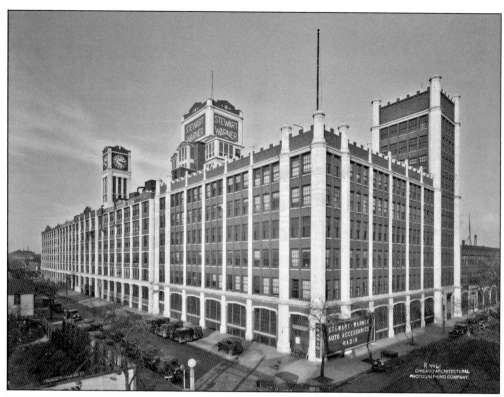

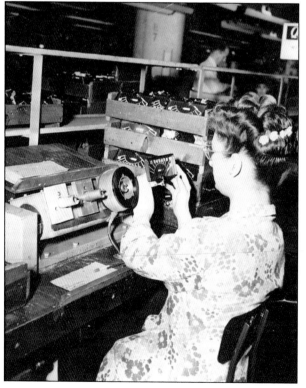

The large Stewart-Warner Corporation factory at 1826 West Diversey Parkway was a landmark for generations of Chicagoans. The multifloor building featured more than one million square feet of space. Stewart-Warner specialized in automotive instruments and lubricating equipment, but it also made consumer products, such as refrigerators and televisions. (Courtesy of the University of Illinois at Chicago Library.)

This woman is calibrating speedometers at the Stewart-Warner factory on the North Side of Chicago. At one time, nearly every automobile in America contained fuel gauges, speedometers, and other mechanical dashboard instruments that were made by this auto parts company. (Courtesy of the Chicago History Museum, ICHi-173774.)

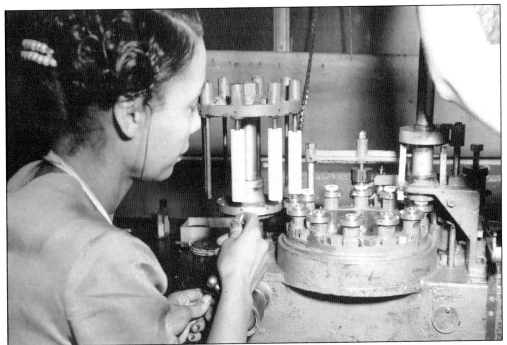

This woman at the Stewart-Warner factory is carefully painting tiny numerals onto odometer wheels that will later be inserted into speedometers. (Courtesy of the Chicago History Museum, ICHi-173775.)

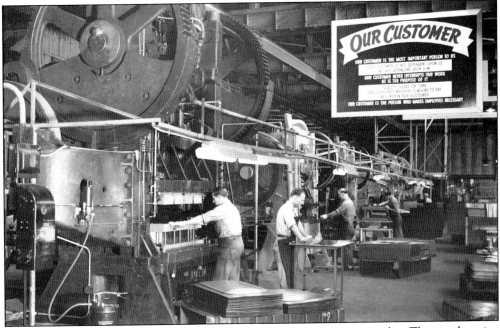

Stewart-Warner employees were constantly reminded to pay attention to quality. This sign hanging over the sheet metal stamping department says to always think about customers, which included many leading manufacturers of airplanes, automobiles, bicycles, boats, buses, motorcycles, tractors, trucks, and other vehicles. (Courtesy of the Chicago History Museum, ICHi-173773.)

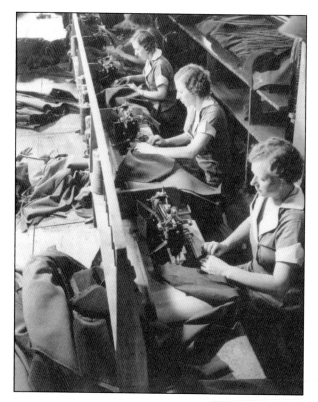

Kroehler Manufacturing Company was the world's largest producer of upholstered furniture. This photograph shows part of the sewing department at the company's factory in west suburban Naperville in the 1940s. (Courtesy of the Naperville Heritage Society.)

Kroehler specialized in chairs, sofas, and other types of living room furniture that was sold by retailers like Montgomery Ward and Sears. But it also produced theater seats, such as this pushback chair being assembled in 1951. (Courtesy of the Chicago History Museum, ICHi-037005.)

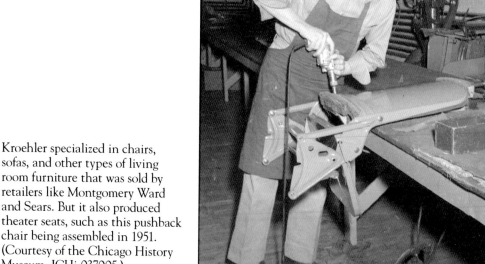

The A.B. Dick Company produced mimeograph machines that were originally based on a design invented by Thomas Edison. Its factory was once located at 732 West Jackson Boulevard in the West Loop, but it moved to north suburban Niles in 1949. (Courtesy of The Henry Ford.)

In the mid-1960s, slot cars were extremely popular. One of the chief producers was Chicago-based Dowst Manufacturing Company, which operated a factory on the city's West Side. Because of the popularity of its products, Dowst eventually changed its name to Strombecker Corporation.

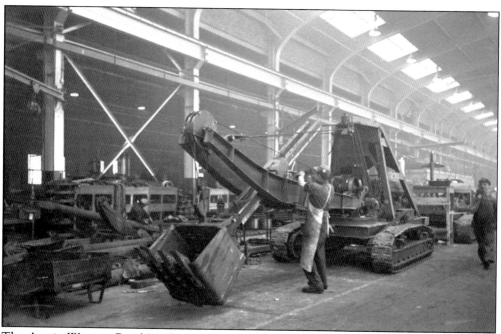

The Austin-Western Road Machinery Company was a prominent producer of construction equipment, such as road graders, rollers, and scrapers. This scene from 1948 shows the power shovel assembly line at the company's factory in west suburban Aurora. (Courtesy of the Newberry Library.)

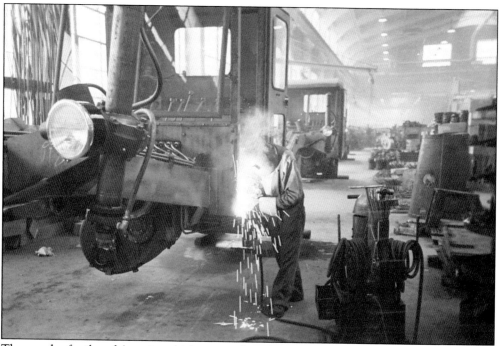

Thousands of miles of American highways and roads were paved with construction equipment made in west suburban Aurora. Austin-Western was well known for its road graders, which were manually welded. (Courtesy of the Newberry Library.)

Between 1918 and 1990, General Electric's Hotpoint division operated several large assembly plants in Chicago and west suburban Cicero. The company originally produced electric irons and kitchen ranges and later built a full line of household appliances. In this 1950 photograph, the body of a range is entering an automated welding station. (Courtesy of the Chicago History Museum, ICHi-173772.)

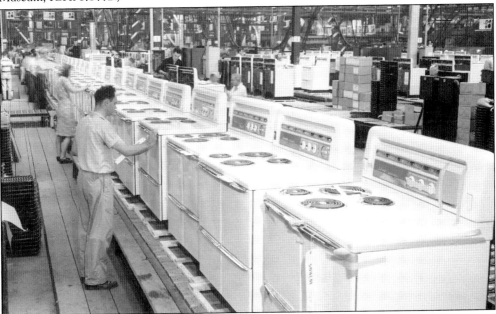

In this 1949 scene, Hotpoint electric ranges pass an inspection station. The company operated large factories at 5600 West Taylor Street in Chicago and 1543 South Fifty-Fourth Street in Cicero that assembled clothes dryers and washers, ovens, and refrigerators. An additional plant in south suburban Chicago Heights made commercial cooking equipment. (Courtesy of the Chicago History Museum, ICHi-039295.)

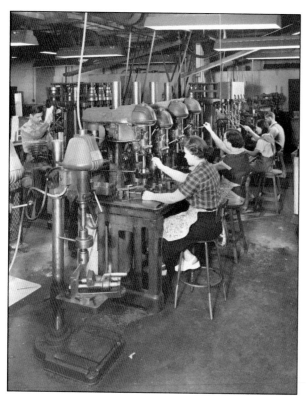

This photograph shows a row of drill presses in operation at a typical late 1940s–era Chicago machine shop that supplied manufacturers with small metal parts needed to make everything ranging from bicycles to televisions. (Courtesy of the Chicago History Museum, ICHi-173816.)

A teletype machine was a printer connected to a telegraph wire that operated like a typewriter. They were widely used by hotels, news bureaus, police departments, stock brokers, railroads, the US military, and other organizations to transmit real-time information. This photograph shows machines being tested at the Teletype Corporation factory on the North Side of Chicago in 1943. (Courtesy of the AT&T Archives and History Center.)

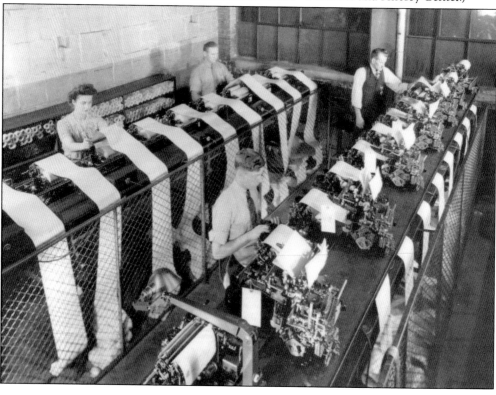

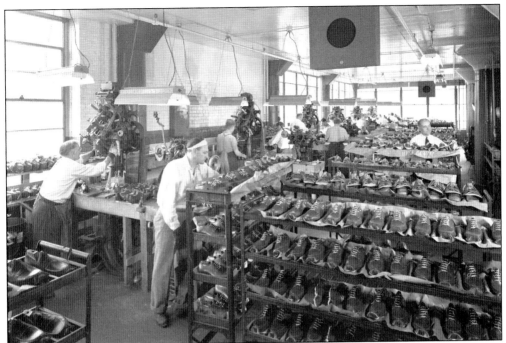

In the 1920s, there were 29 shoe factories in Chicago that produced almost nine million pairs of shoes annually. The largest was Florsheim Shoe Company, which employed 2,500 people at five local plants. (Courtesy of the Chicago History Museum, HB-12633-M, Hedrich-Blessing Collection.)

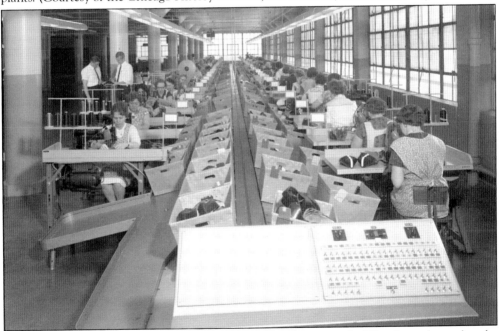

In 1949, the Florsheim Shoe Company built a modern factory in the West Loop, located at the corner of Adams and Clinton Streets. It featured state-of-the-art production equipment, such as this automatic conveyor system. (Courtesy of the Chicago History Museum, HB-27125, Hedrich-Blessing Collection.)

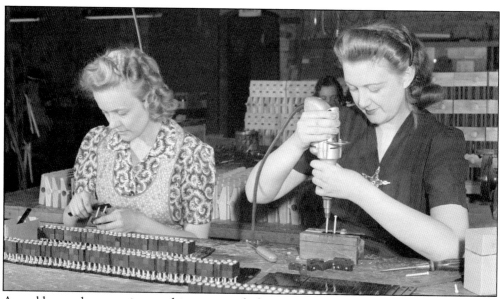

Assemblers used pneumatic screwdrivers to attach the numerous parts needed to create Gulbransen pianos and organs. In 1904, Axel Gulbransen established the company in Chicago. It originally made player pianos and introduced its first organ in 1928. Over the years, the company was responsible for many firsts in the music industry, including the world's first transistor organ in 1962. (Courtesy of the Library of Congress, Prints & Photographs Division, FSA/OWI Collection.)

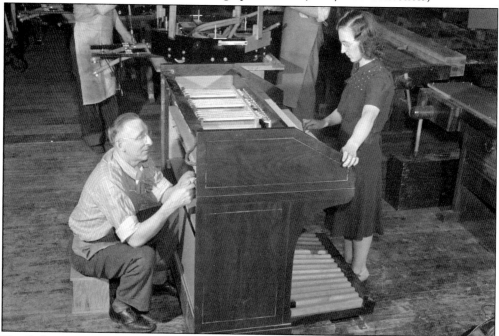

The Gulbransen Piano Company was the world's largest manufacturer of player pianos. Its trademark, Easy-at-the-Pedals, and its slogan, "Easy to Play," were well known. For decades, Gulbransen's factory was located at 816 West Kedzie Boulevard in Chicago. The company produced more than 500,000 pianos until it went out of business in 1969. (Courtesy of the Library of Congress, Prints & Photographs Division, FSA/OWI Collection.)

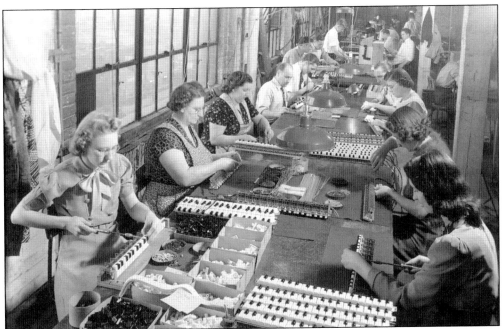

The Hammond Organ Company employed more than 1,000 people at its Chicago factory in the 1950s. This photograph shows keyboards being assembled at 4200 West Diversey Avenue on the Northwest Side of the city. (Courtesy of the Chicago History Museum, ICHi-038568; Kaufmann & Fabry Company, photographer.)

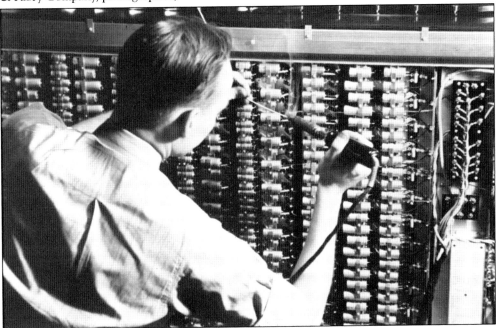

Hammond specialized in electric organs that required assemblers to solder complex components, like this relay cabinet. The heart of the organ was a tone wheel, a small metallic disk that rotated on a constant-speed shaft driven by a synchronous motor. (Courtesy of the Chicago History Museum, ICHi-173769; Williams & Meyer, photographer.)

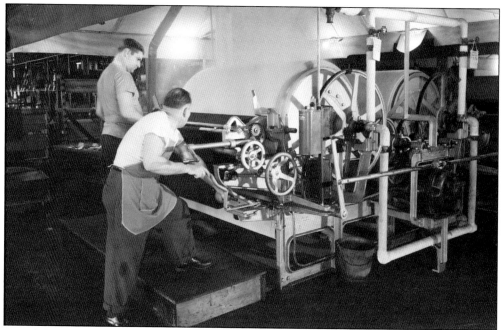

Founded on the West Side of Chicago in 1876 by a German immigrant, B. Kuppenheimer and Company was a men's clothing firm. This photograph from the late 1940s shows workers shooting steam into fabric at the company's factory, located at 3040 West Lake Street. (Courtesy of the Chicago History Museum, ICHi-173811.)

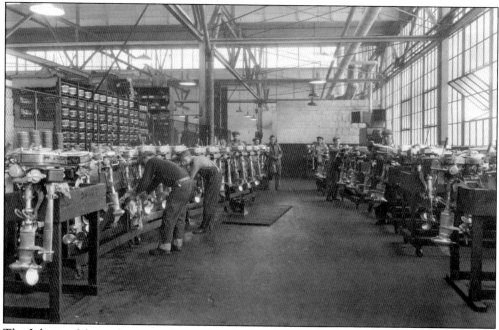

The Johnson Motor Company in north suburban Waukegan was one of the world's largest manufacturers of outboard engines. This photograph shows the final trim room, where products are being cleaned and polished before they are packaged for shipment. (Courtesy of the Waukegan Historical Society.)

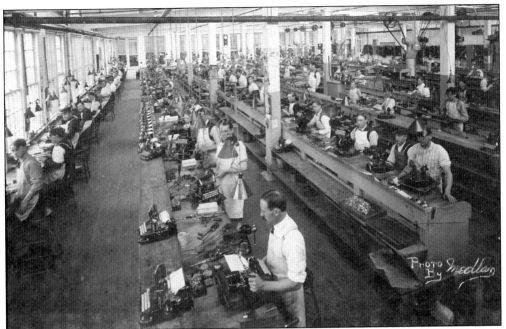

Between 1896 and 1928, the Oliver Typewriter Company operated a factory in northwest suburban Woodstock. In the early 1920s, it was the largest typewriter manufacturer in the world. The small, rural town was also home to the Woodstock Typewriter Company. (Courtesy of the McHenry County Historical Society.)

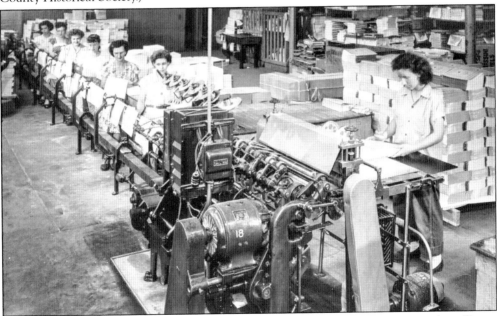

Printing was a major industry in Chicago during the 20th century. Companies such as Cuneo Press, Donnelley, and W.F. Hall operated large plants that mass-produced books, encyclopedias, magazines, mail-order catalogs, telephone directories, and many other items. This photograph shows part of the binding department at Rand McNally, which specialized in business directories, maps, railroad guides and timetables, road atlases, and textbooks. (Courtesy of the Newberry Library.)

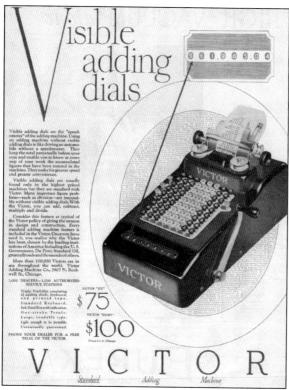

The Victor Adding Machine Company was located on the North Side of Chicago at 3900 North Rockwell Street. Its products were used in thousands of businesses. The company called itself "the world's largest exclusive manufacturers of adding machines."

Clothing and garment manufacturers once employed thousands of immigrants on the West Side of Chicago. This 1950 photograph shows workers hand-stitching men's suits at Society Brand Clothes, Inc., which was located at 416 South Franklin Street. The company's slogan was "for young men and men who stay young." (Courtesy of the Chicago History Museum, ICHi-173810.)

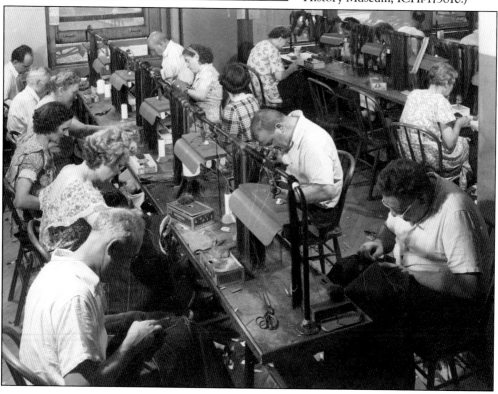

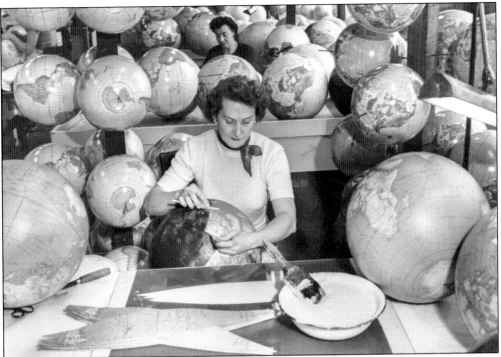

Chicago was once the world's largest producer of globes. It was home to manufacturers such as Denoyer-Geppert, George F. Cram and Company, Rand McNally, Replogle, and Weber Costello. (Courtesy of the Newberry Library.)

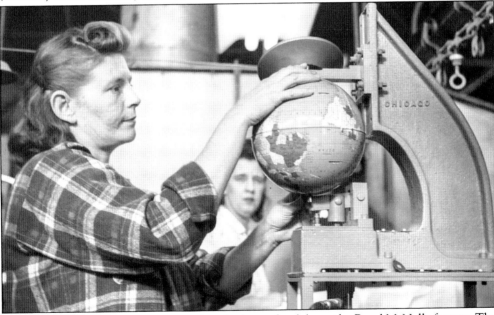

This photograph shows a woman riveting the base of a globe at the Rand McNally factory. The machine she is using was made by another local manufacturer, the Chicago Rivet & Machine Company. Rand McNally's factory was located in the South Loop at 536 South Clark Street until 1952, when it moved to north suburban Skokie. (Courtesy of the Newberry Library.)

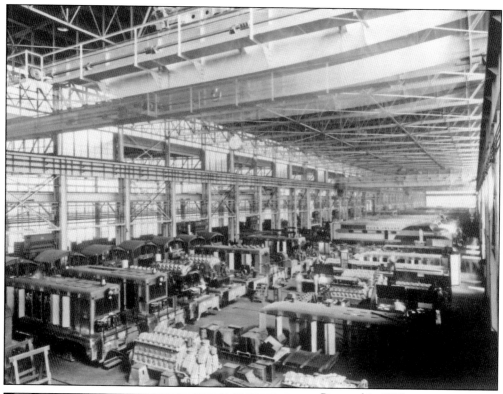

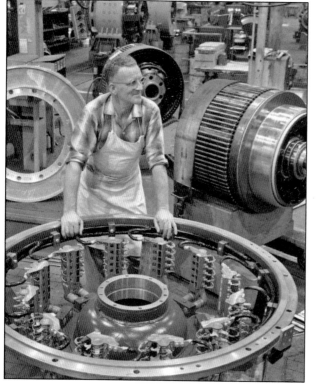

Pictured in 1939, numerous locomotives are in various states of assembly at the General Motors EMD plant in west suburban McCook (the plant's mailing address was LaGrange). The machines in the foreground are 600- and 900-horsepower diesel yard switchers. Streamlined passenger locomotives are under construction in the background. (Courtesy of General Motors LLC.)

This photograph from 1958 shows a few of the massive traction motors and other electromechanical components needed to assemble a diesel-electric locomotive at the GM Electro-Motive Division plant in McCook. (Courtesy of General Motors LLC.)

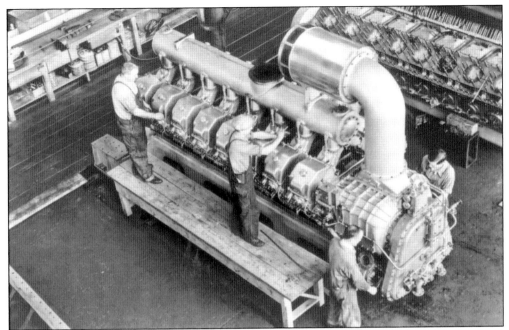

In this view from 1937, workers at the GM EMD factory are dwarfed by a huge 16-cyclinder diesel engine that will soon be installed in a new locomotive that is under construction elsewhere in the building. (Courtesy of General Motors LLC.)

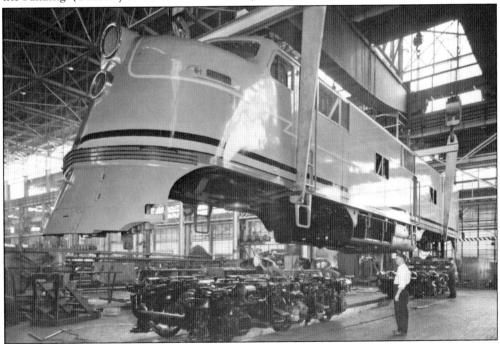

The General Motors' Electro-Motive Division plant produced streamlined locomotives in the late 1930s that helped transform Depression-weary railroads. Design features borrowed from the automotive industry gave EMD machines a sleek, modern appearance that appealed to the public. (Courtesy of General Motors LLC.)

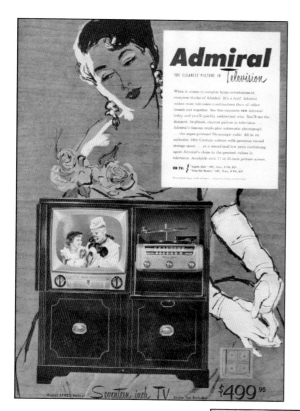

From the mid-1930s to the early 1970s, Admiral Corporation was a leading producer of household appliances, phonographs, radios, and televisions. Its main Chicago factory was located at 3800 West Cortland Street. But, to keep up with skyrocketing demand for its products, Admiral opened a new factory in the northwest suburb of Harvard in 1947.

In the 1960s, many manufacturers converted their electromechanical systems to electronics. This woman is inspecting a circuit board at Panellite, Inc., on the North Side of Chicago. The company eventually became the Panalarm division of Ametek, a manufacturer of analytical instruments and precision components. (Courtesy of the University of Illinois at Chicago Library.)

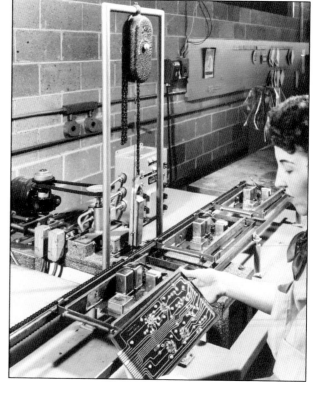

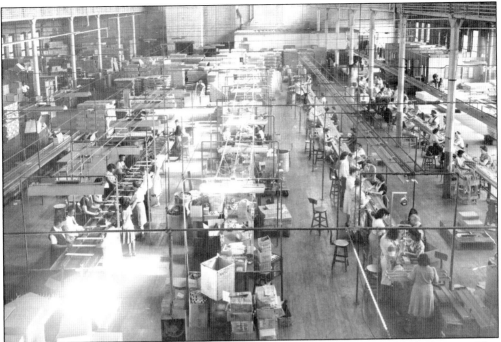

Chicagoland has long been a major producer of commercial and residential light fixtures. This photograph from the early 1950s shows an overview of the Electro Manufacturing Corporation factory. (Courtesy of the Chicago History Museum, ICHi-020414.)

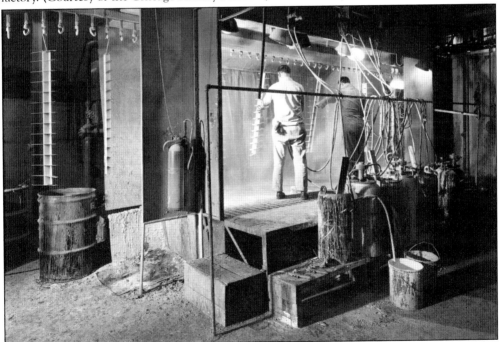

This photograph depicts a paint booth at Curtis Lighting Company. Metal parts used in fluorescent light fixtures are suspended on an overhead conveyor. (Courtesy of the Chicago History Museum, ICHi-173817.)

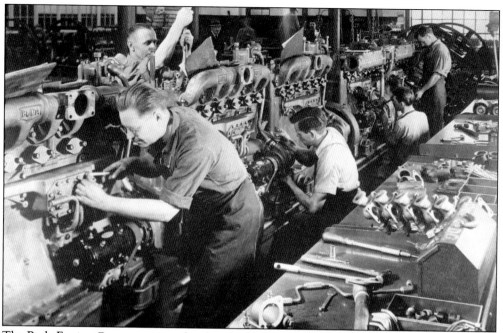

The Buda Engine Company in south suburban Harvey was a major manufacturer of heavy-duty diesel engines. Its products were used by a wide variety of companies that made construction equipment, tractors, and trucks. Buda was acquired by the Allis-Chalmers Company in 1953. (Courtesy of the Chicago History Museum, ICHi-173776.)

A new batch of jukeboxes fresh off the assembly line is ready to be shipped around the world. The stenciled letters on the wood crates read, "From J.P. Seeburg Corp., World's Leading Manufacturers of Automatic Musical Instruments, Chicago, USA." (Courtesy of the Chicago History Museum, HB-10083-H, Hedrich-Blessing Collection.)

Four

THE BIG THREE

Although there once were thousands of manufacturers in Chicagoland, three companies stood out among them. International Harvester, Pullman, and Western Electric employed the most people and operated some of the largest manufacturing complexes in the United States.

For decades, International Harvester was synonymous with manufacturing in Chicago. Between 1847 and 1972, it mass-produced all types of agricultural equipment in the city. By the early 1920s, the vertically integrated company had nine sites in the area, including its own steel mill on the Southeast Side.

International Harvester's operations were based at two large facilities on the Southwest Side of Chicago. The McCormick Works in the Canalport neighborhood was open from 1873 to 1961. The nearby Tractor Works was an equally impressive part of the local industrial landscape from 1910 to 1972.

Those two complexes alone covered more than 170 acres and employed more than 6,000 people. Other International Harvester locations included the Deering Works on the North Side and the West Pullman Works on the South Side.

In 1880, George Pullman purchased 4,000 acres of land near Lake Calumet, 14 miles south of downtown Chicago. He also built a controversial town for his workers near the factories.

Over the next 100 years, the company built thousands of passenger and freight railroad cars at the sprawling complex. In addition, Pullman produced buses, streetcars, mass-transit cars, and other types of products.

By 1910, the company employed 10,000 people at its multibuilding complex. As railroad car construction switched from wood to steel, Pullman developed new production tools and techniques, such as riveting and welding. It also pioneered lightweight materials like aluminum and stainless steel. A merger in 1929 changed the company's name to Pullman-Standard.

Western Electric served as the manufacturing arm of the American Telephone and Telegraph Company for more than 100 years. It specialized in telephones and switching equipment but also produced many other types of products, including motion picture sound systems, dishwashers, sewing machines, and vacuums.

Western Electric began manufacturing telegraph equipment in Chicago in the early 1870s and was acquired by the American Bell Telephone Company (predecessor to AT&T) in 1881.

When Western Electric outgrew its factory located at Clinton and Van Buren Streets in 1904, it moved to west suburban Cicero and built a huge complex that became known as the Hawthorne Works. The facility eventually grew into a five-million-square-foot operation that employed more than 40,000 people.

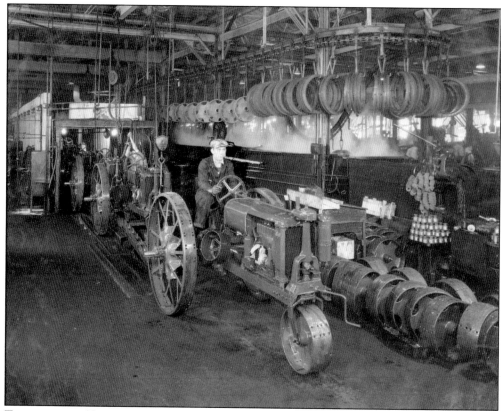

To generations of farmers around the world, Chicago was synonymous with red tractors, manufactured by the International Harvester Company at a sprawling complex on the Southwest Side of the city. Farmall machines, such as these F-12 tractors coming off the assembly line in 1934, were proudly stamped "Chicago USA." (Courtesy of the Wisconsin Historical Society, WHi-8269.)

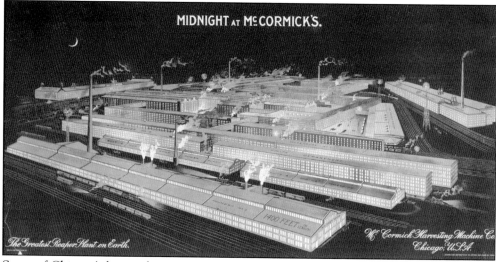

Some of Chicago's largest factories, such as the McCormick Works in the city's Canalport neighborhood, operated day and night, as illustrated in this poster from 1900. The huge complex was open from 1873 to 1961. (Courtesy of the Wisconsin Historical Society, WHi-3556.)

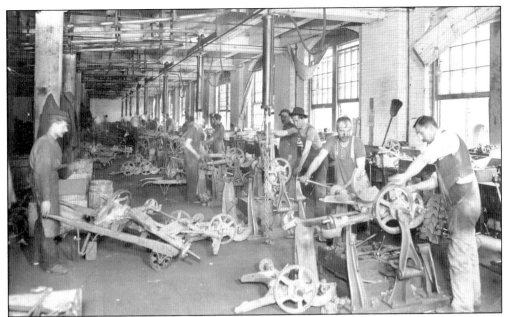

Before the development of the moving assembly line, products were assembled by teams of workers who stood at individual workbenches and built an entire product. This view from 1900 shows a group of men assembling mowers at the McCormick Works on the Southwest Side of Chicago. (Courtesy of the Wisconsin Historical Society, WHi-9750.)

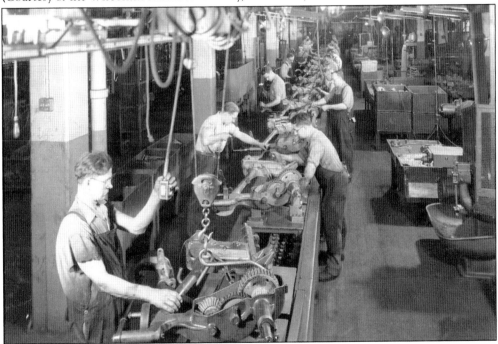

The advent of the moving assembly line dramatically changed manufacturing operations. It enabled workers to stand at one spot and perform assembly tasks as products moved past them on a conveyor. This 1936 picture shows mower subassemblies moving down a long production line at the McCormick Works. (Courtesy of the Wisconsin Historical Society, WHi-8920.)

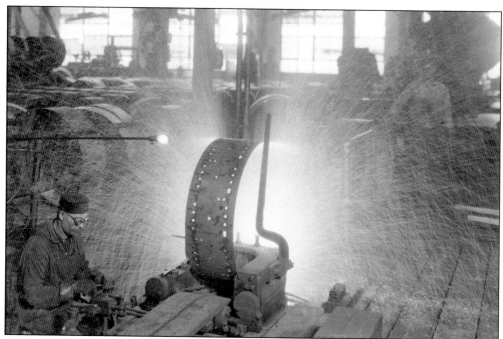

Covered in sparks, this worker is welding a metal tractor wheel at the International Harvester factory in 1929. Today, dangerous work such as this is often done by robots. (Courtesy of the Wisconsin Historical Society, WHi-8178.)

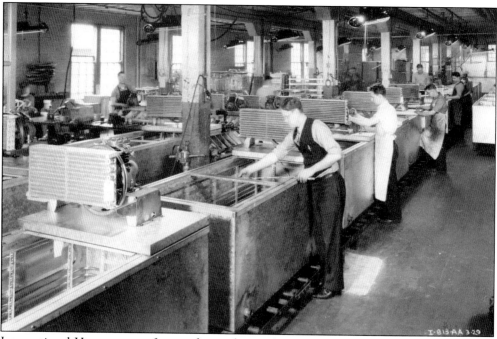

International Harvester was famous for producing farm tractors and agricultural equipment. However, the company also made other products, such as portable gas engines, refrigerators, and trucks. In this 1937 view inside the West Pullman Works, workers are assembling large milk coolers used by dairy farmers. (Courtesy of the Wisconsin Historical Society, WHi-51791.)

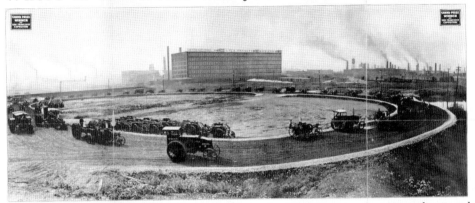

Mogul Tractor Testing Track at Chicago
Where in the World will you find another like it?

Every Mogul gets a thorough work-out on this track. When it comes to you we know and you know it will do the work you bought it for

Thousands of Mogul 8-16 tractors have gone from this track to the farm. Every one pulled its full load at drawbar and belt before shipment.

Thousands of farmers, as a consequence, are boosting this king of small-farm tractors to the limit. "Cheaper than horses," says one; "Tireless," says another; "Can be used for so many different jobs," says a third.

Mogul 8-16 completely overturns all the old ideas of power farming. Instead of an emergency outfit, to be used only when the need is great, it's a practical, everyday farm tool—as necessary as a pump and as useful as a wagon.

Put one to work. Be one of the next thousand farmers to rise up and bless the day they bought a Mogul 8-16 tractor.

International Harvester Company of America
Chicago USA

Grand Prize Winner at San Francisco

$675 CASH F.O.B. Chicago

One of International Harvester's first tractors was called the Mogul. After the rugged machines were assembled, they were driven on a test track located next to the factory. (Courtesy of the Wisconsin Historical Society, WHi-4441.)

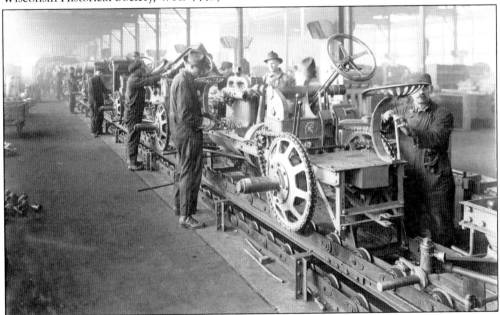

The 8-16 was a popular machine produced at International Harvester's Tractor Works. The huge factory was located at 2600 West Thirty-First Boulevard. It covered 80 acres, employed more than 3,000 people, and was in operation from 1910 to 1972. (Courtesy of the Wisconsin Historical Society, WHi-7258.)

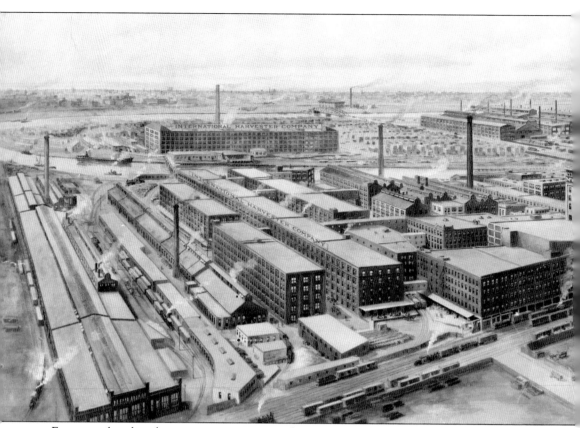

For many decades, the most impressive manufacturing complex in Chicago was International Harvester's McCormick Works on the Southwest Side of the city. This 90-acre site featured 45 buildings that employed thousands of people between 1873 and 1961. In the background is the

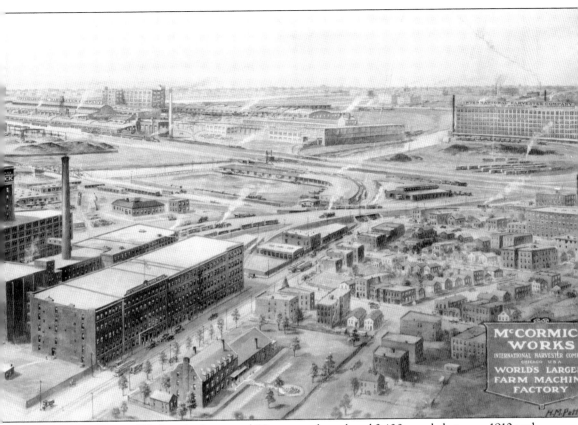

company's Tractor Works, which covered 80 acres and employed 3,400 people between 1910 and 1972. (Courtesy of the Chicago History Museum, ICHi-173819.)

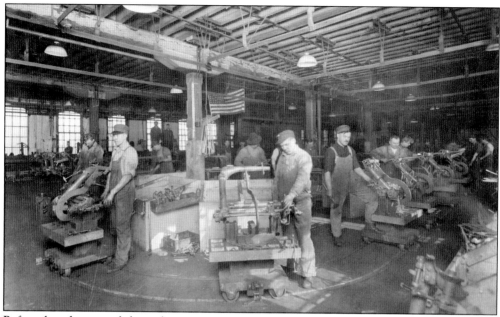

Before the adoption of chain-driven conveyors, workers manually pushed carts from station to station on assembly lines. This image shows assemblers making components for grain binders at the McCormick Works. By the time this photograph was taken in the 1910s, the company had already built almost two million of the machines in Chicago. (Courtesy of the Wisconsin Historical Society, WHi-8182.)

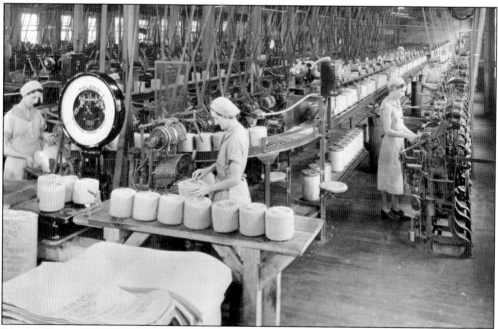

The McCormick Works included a twine mill that occupied 500,000 square feet and produced 30,000 tons of material per year. Workers processed it completely from raw fiber into packages of balled twine that were used with wheat binders and other types of farm equipment. (Courtesy of the Wisconsin Historical Society, WHi-8897.)

This 1926 advertisement features an aerial view of International Harvester's Tractor Works on the Southwest Side of Chicago. The large factory opened in 1910 and produced more than three million machines before it closed in 1972. (Courtesy of the Wisconsin Historical Society, WHi-10822.)

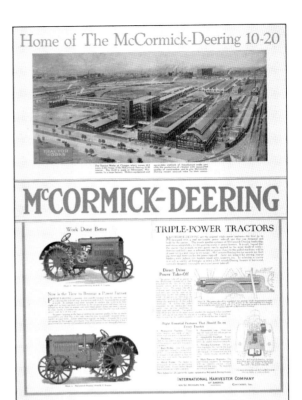

Here, Harvester Works employees are building sickle bars for mowers. The factory was located at Western and Blue Island Avenues in Chicago. (Courtesy of the Wisconsin Historical Society, WHi-8304.)

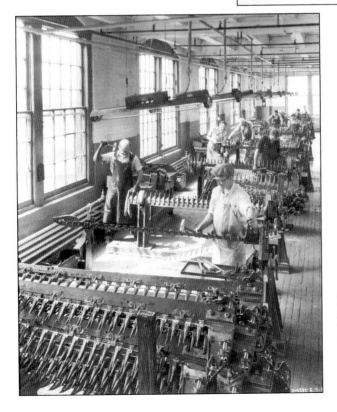

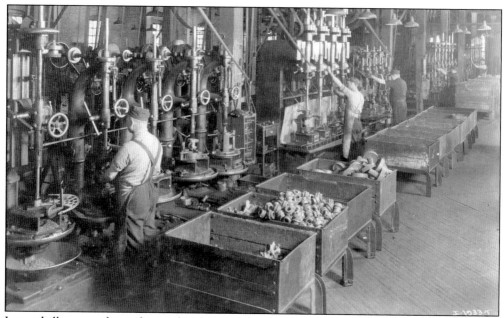

Large drill presses driven by overhead line shafts and belts were used to produce many of the metal parts used in International Harvester's diverse line of agricultural products. This scene from 1930 is inside the company's Deering Works, located at Clybourn and Fullerton Avenues on the North Side of Chicago. This large factory became a victim of the Great Depression and closed a few years later. (Courtesy of the Wisconsin Historical Society, WHi-9631.)

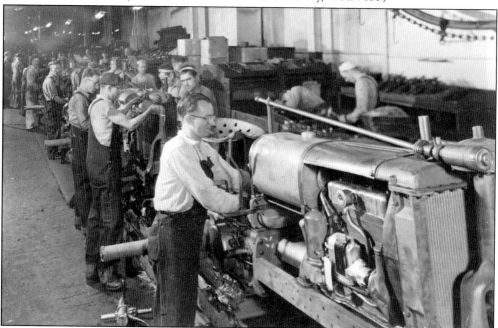

Farmall F-14 machines move down the assembly line at International Harvester's Tractor Works in 1938. More than 27,000 copies of this popular farm tractor were produced on the Southwest Side of Chicago before the outbreak of World War II. (Courtesy of the Wisconsin Historical Society, WHi-12234.)

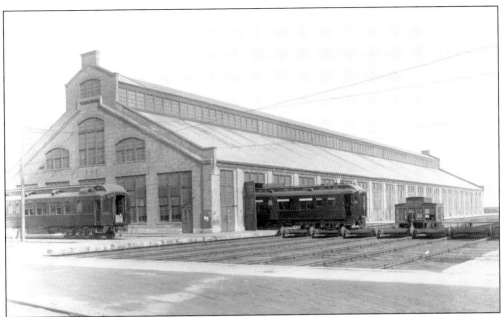

The Pullman factory produced railroad passenger cars on the South Side of Chicago from 1881 to 1981. The transfer table was an important part of the large complex, which stretched between 111th and 115th Streets. It enabled workers to laterally move railroad cars to different parts of the assembly line that stretched from one end of this building to the other. (Courtesy of the Pullman State Historic Site.)

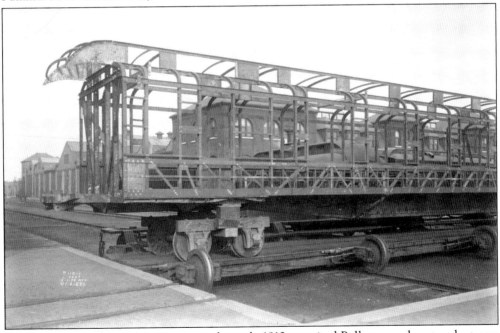

The switch to steel car construction in the early 1910s required Pullman workers to adopt new production tools and techniques This photograph shows the steel frame of a passenger car sitting on the transfer table. It is ready to be moved a few feet to one of the multiple bays used on the assembly line. (Courtesy of the Pullman State Historic Site.)

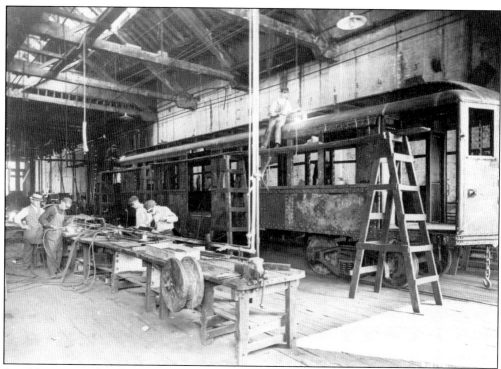

In addition to railroad cars, Pullman also produced buses, streetcars, and mass-transit cars. This photograph from the 1910s shows a steel subway car being assembled for New York City's Interborough Rapid Transit Company. (Courtesy of the Pullman State Historic Site.)

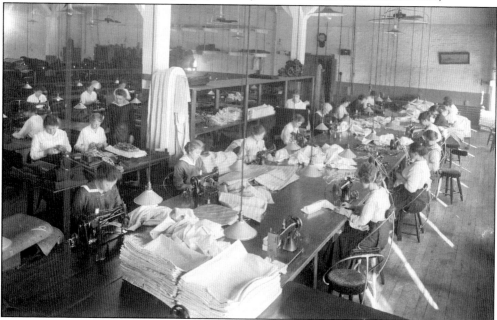

Pullman employed hundreds of people to produce the interiors of its passenger cars. This early-1900s photograph shows a group of women sewing fabric for chairs and couches. (Courtesy of the Chicago History Museum, ICHi-019682.)

During the late 1940s and early 1950s, production activity at Pullman ramped up as many railroads ordered new fleets of lightweight, streamlined passenger cars. The railroad companies were desperately trying to compete against the onslaught of airplanes and automobiles. (Courtesy of the Pullman State Historic Site.)

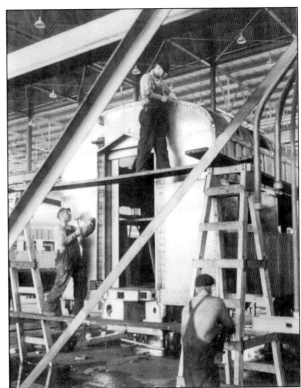

One of the most unusual products ever built in Chicago was the Snow Cruiser. The 55-foot-long vehicle was 19 feet wide, 16 feet tall, and weighed 36 tons. It emerged from the Pullman factory in the fall of 1939. The vehicle was used by Adm. Richard Byrd on his 1940 Antarctic expedition. (Courtesy of the Pullman State Historic Site.)

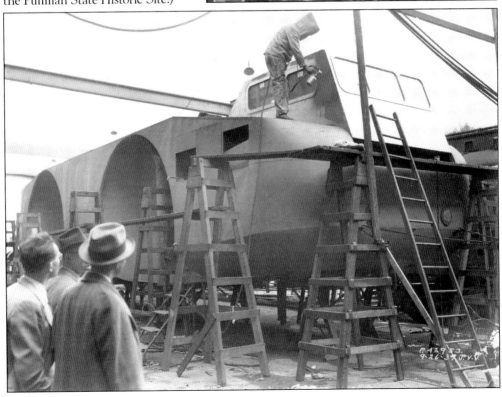

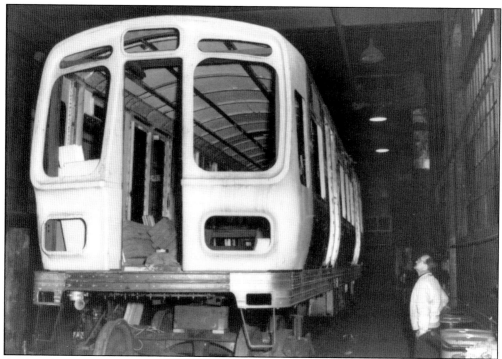

A 2001-class rapid transit car is under construction at the Pullman factory in 1964. The cars were made out of lightweight materials such as aluminum and fiberglass. They were used on the Chicago Transit Authority's "L" system until the early 1990s. (Courtesy of the Krambles-Peterson Archive.)

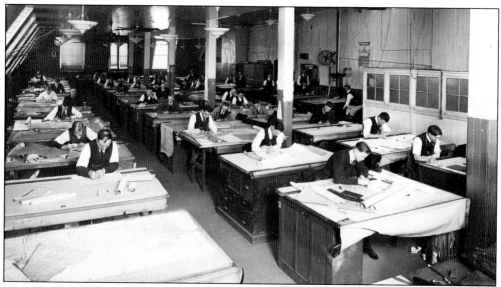

In the days before computers, designing railroad cars was a laborious process. This 1917 photograph shows the Pullman drafting department. Men hunched over desks used compasses, pencils, protractors, slide rules, and other basic instruments to create blueprints and technical drawings that were sent to the factory floor for production. (Courtesy of the Chicago History Museum, ICHi-173714.)

To keep up with increased demand, Pullman adopted new types of assembly processes and more efficient production tools. This photograph from 1949 shows workers in the metal fabrication department using automatic welding equipment. (Courtesy of the Pullman State Historic Site.)

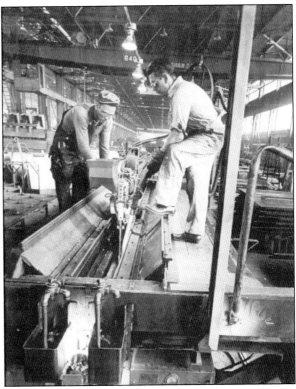

In addition to railroad cars, Pullman produced all-steel bodies for automobile manufacturers such as Packard, Peerless, and Willys-Overland. This photograph shows a few of the 13,000 bodies built for the Packard Motor Car Company in the early 1920s. Pullman also mass-produced wood phonograph cabinets for the Edison Company. (Courtesy of the Chicago History Museum, ICHi-173715.)

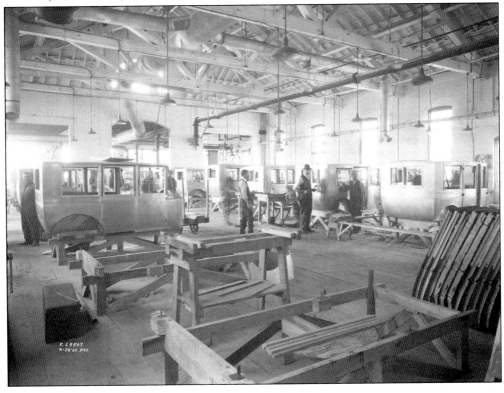

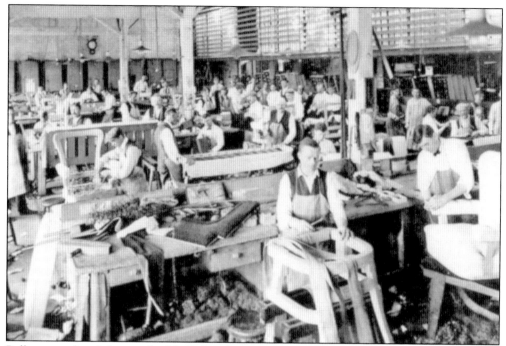

Pullman employed thousands of skilled craftsmen, including many recent European immigrants. This photograph shows the furniture upholstery department where seats and other items used in passenger cars were produced. (Courtesy of the Pullman State Historic Site.)

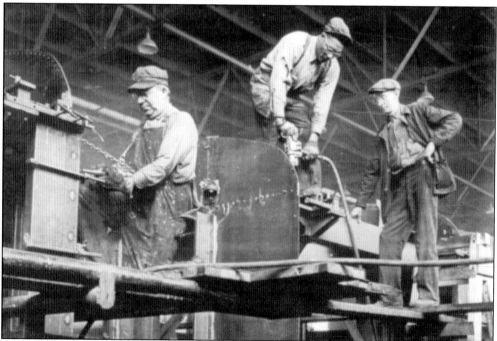

Pullman pioneered railroad car construction techniques, like riveting. Early car bodies were made from wood, but the company eventually developed aluminum and stainless-steel structures that were lighter, safer, and easier to maintain. (Courtesy of the Pullman State Historic Site.)

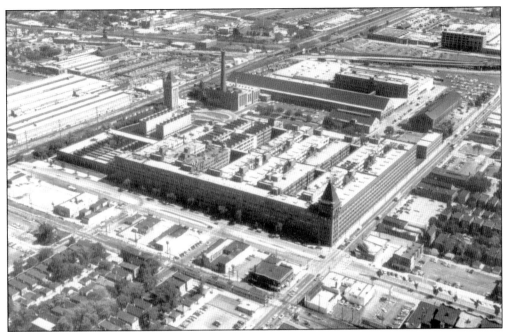

Western Electric's Hawthorne Works, located at the corner of Cermak Road and Cicero Avenue in west suburban Cicero, was one of the largest manufacturing complexes in the United States. This 1974 aerial view, looking southeast, shows how the sprawling facility dominated the local landscape. (Courtesy of the AT&T Archives and History Center.)

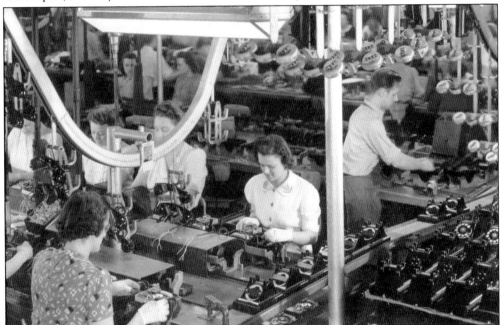

Western Electric once boasted that it manufactured "43,000 varieties of telephone apparatus." This 1941 photograph shows rotary-dial telephones being assembled at the Hawthorne Works. At one time, more than 50 percent of all telephones in the world were assembled there. (Courtesy of the AT&T Archives and History Center.)

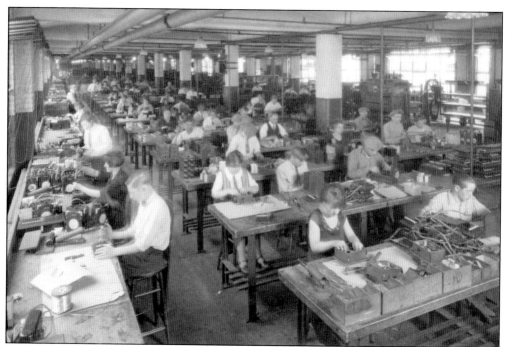

Inside the multibuilding Hawthorne Works, more than 40,000 people designed, assembled, and tested a wide variety of switchboards, relays, switching systems, and other state-of-the-art telecommunications equipment. (Courtesy of the AT&T Archives and History Center.)

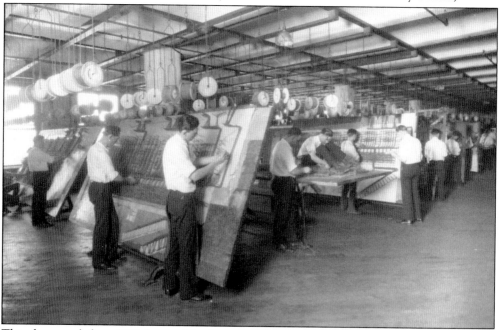

This photograph from 1925 shows wiring harnesses for switchboards being assembled on large jigs inside one corner of the massive Hawthorne Works complex. Overhead spools contain numerous types of wire in multiple sizes for different assembly applications. (Courtesy of the AT&T Archives and History Center.)

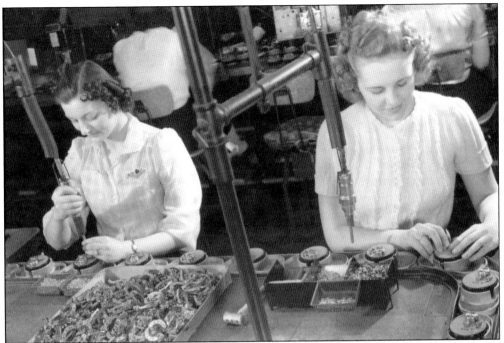

In 1919, the Hawthorne Works produced the first desktop telephones equipped with rotary dials. This scene inside the factory 20 years later shows dials being assembled with pneumatic screwdrivers. (Courtesy of the AT&T Archives and History Center.)

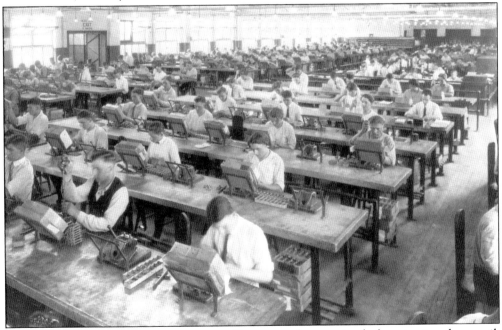

Telephone relays required a repetitive assembly process that consisted of putting together a coil, armature, contact springs, and insulators in a fixture. The parts were fastened together with four screws. Each assembly took approximately one minute to complete. (Courtesy of the AT&T Archives and History Center.)

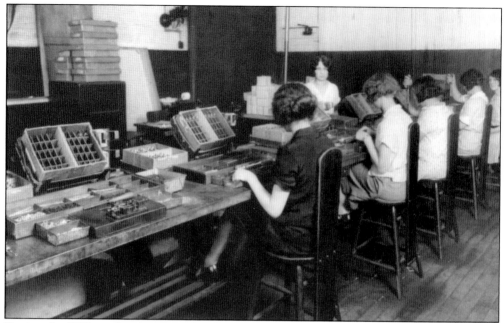

During the 1920s and early 1930s, the Hawthorne Works was the site of a series of landmark human behavior studies. Scientists from Harvard University examined how fatigue, monotony, and supervision on various assembly lines could dramatically affect productivity. (Courtesy of the AT&T Archives and History Center.)

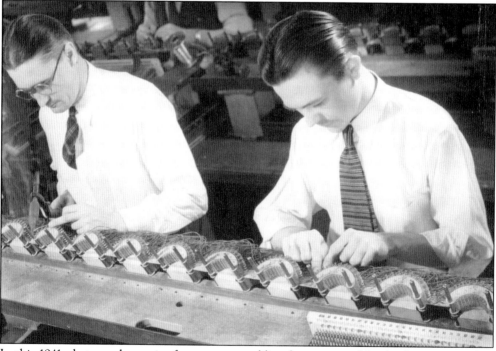

In this 1941 photograph, a pair of men are assembling long terminal banks that were used in automated telephone exchanges. The technology enabled AT&T's Bell System to handle increasing call volumes. (Courtesy of the AT&T Archives and History Center.)

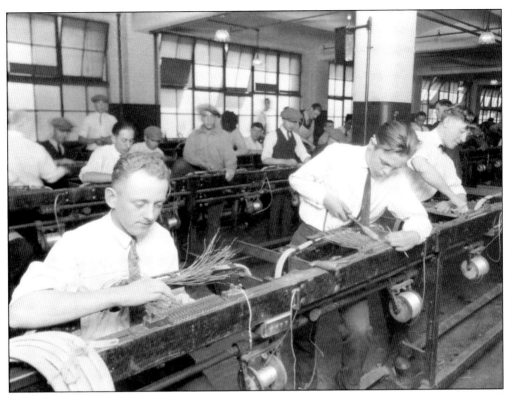

Wire processing was an important activity inside Western Electric's Hawthorne Works. The factory turned 45,000 tons of copper into wire each year and accounted for more than 75 percent of all the lead cable manufactured in the United States. (Courtesy of the AT&T Archives and History Center.)

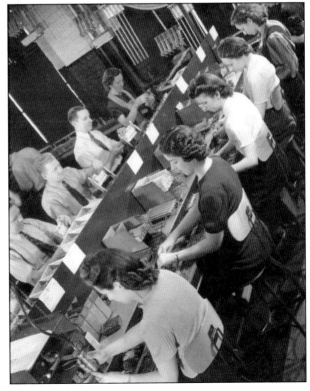

Early telecommunications equipment required hundreds of complex, hand-assembled components. To keep operations running smoothly, the five-million-square-foot Hawthorne Works pioneered many types of quality-control practices and principles. (Courtesy of the AT&T Archives and History Center.)

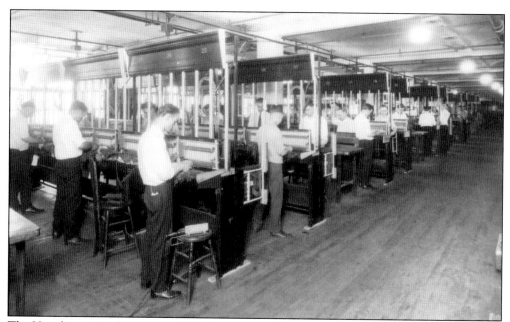

The Hawthorne Works was one of the largest manufacturing complexes in the world and home to many innovations, ranging from talking pictures to push-button telephones. For decades, it was synonymous with cutting-edge telecommunications technology. The Hawthorne Works also was the first factory in the world to use widespread visual inspection and testing to detect manufacturing flaws and improve quality. (Courtesy of the AT&T Archives and History Center.)

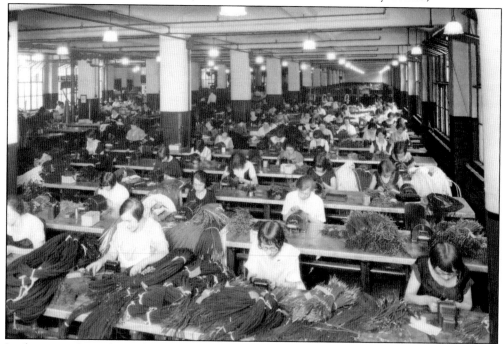

In this scene from the mid-1920s, rows of women in the telephone cord finishing department inspect, trim, and bundle their work. Cords were made from copper wiring, wood pulp insulation, and a woven silk covering. (Courtesy of the AT&T Archives and History Center.)

Five

CHICAGO'S FINEST HOUR

After the United States entered World War II in 1942, Chicago-area manufacturers converted their factories to build all types of military items. Plants that made appliances, farm implements, and toys were retooled to mass-produce guns, planes, and tanks.

The Windy City became one of the key cogs in America's Arsenal of Democracy. More than 1,400 local companies were involved in the war effort. By mid-1944, Chicago manufacturers were accountable for $8 billion in war-related contracts. More than $1 billion was spent on factory construction during the war, including more than 300 new buildings.

Companies such as Alcoa, American Can, Chrysler, Douglas Aircraft, General Motors, Revere Copper and Brass, and Studebaker built massive plants that operated 24 hours a day and pumped out aircraft engines, ordnance, torpedoes, and other items.

Every battlefront of World War II was fought using products that were made in Chicago factories. Trucks built on the Southwest Side rolled through the desert sands of North Africa; ships produced on the North Side patrolled the warm waters of the South Pacific; and walkie-talkies made on the West Side were carried by soldiers across the frozen fields and forests of Europe.

During World War II, local companies made the majority of all electronics and communications equipment used by the US military. Products ranged from advanced radar units to ship-to-shore radio sets.

Fifty Chicagoland manufacturers produced parts, including powerful engines, used in the B-29 bomber, the aircraft that is credited with ending the war. Chicago's Victor Adding Machine Company produced the Norden bombsight, the top secret device that gave US aircraft unprecedented accuracy.

Even companies that made toys joined the war effort. Chicago Roller Skate Company mass-produced small parts for guns and shells; Radio Flyer modified its wagon-stamping machines to make five-gallon fuel cans; and Schwinn made metal aircraft components, ammunition, artillery shell casings, and electrical devices.

Because thousands of men were away on active military duty, women replaced them on many assembly lines. In fact, women made up more than 60 percent of the workforce at local manufacturers, such as Bendix Aviation, Shure Brothers, and Webster-Chicago.

Many Chicagoland companies proudly displayed the blue and red Army-Navy "E" flag outside their factories. Only about five percent of the nation's 85,000 defense suppliers earned the coveted award for excellence in manufacturing. But 10 percent of the recipients were in Illinois, including 233 in Chicago and 74 in the suburbs.

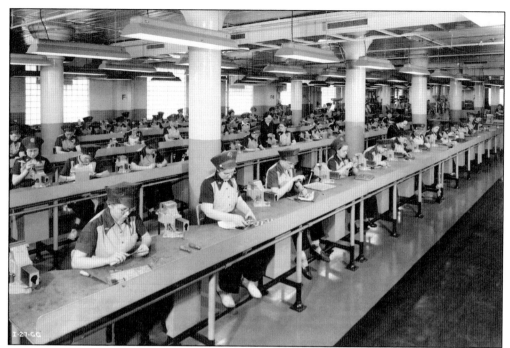

During World War II, women kept Chicago's factories operating around the clock. This 1943 view shows torpedo parts being assembled inside International Harvester's factory on the city's Southwest Side. (Courtesy of the Wisconsin Historical Society, WHi-26364.)

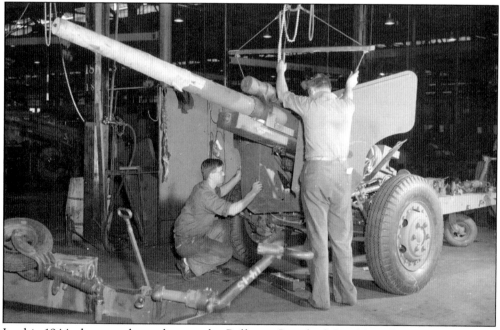

In this 1944 photograph, workers at the Pullman-Standard Car Manufacturing Company plant in Hammond, Indiana, are assembling a three-inch cannon. The railroad car company produced thousands of similar weapons during World War II. (Courtesy of the Pullman State Historic Site.)

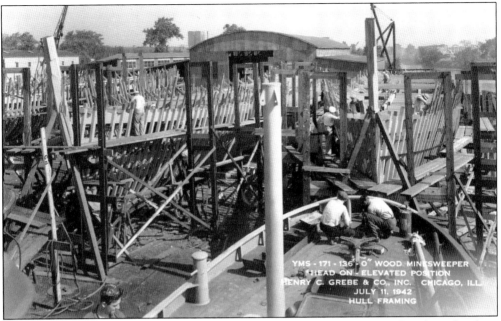

The Henry C. Grebe Company shipyard on the North Side of Chicago produced 136-foot-long minesweepers for the US Navy. Several wood hulls are under construction in this July 1942 photograph. (Courtesy of the Chicago Maritime Museum.)

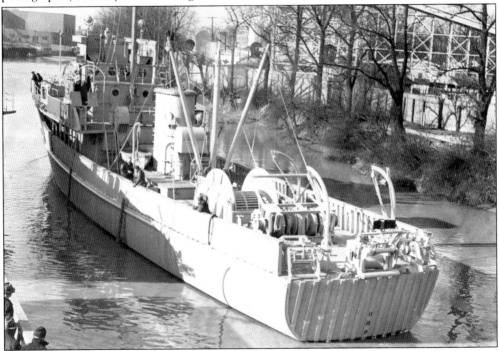

In this March 1943 photograph, a minesweeper has just left the Henry C. Grebe Company. Part of the famous "Bobs" roller coaster at Riverview Amusement Park, located on the opposite side of the Chicago River from the shipyard, is visible in the upper right corner. (Courtesy of the Chicago Maritime Museum.)

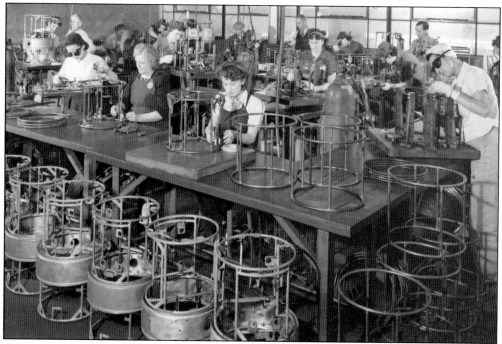

Arnold, Schwinn & Company's metal tube bending skills normally used to make bicycles were adapted to wartime production applications, such as making aircraft components. (Courtesy of Mark Mattei.)

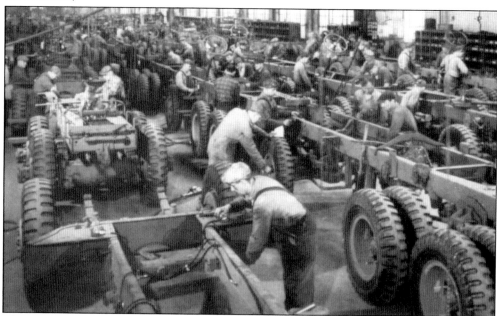

The Diamond T Motor Car Company mass-produced heavy-duty trucks for the US Army at its factory on West Twenty-Sixth Street. This view from 1942 shows Type 980 tank hauler chassis being assembled. These rugged trucks built on the Southwest Side of Chicago will soon be in action on the battlefields of Europe and North Africa. (Courtesy of Nynehead Books/ Roundoak Publishing.)

Thousands of vehicles made in Chicago by the Diamond T Motor Car Company served "on active duty at every major front" during World War II. This early-1940s advertisement explains how the company's six-wheel-drive trucks haul tanks and other vital supplies over rough terrain.

Like many Chicago manufacturers, Diamond T was proud of its war effort. "A brilliant engineering staff and a redoubled production machine are devoted today to the winning of the war," proclaims this ad.

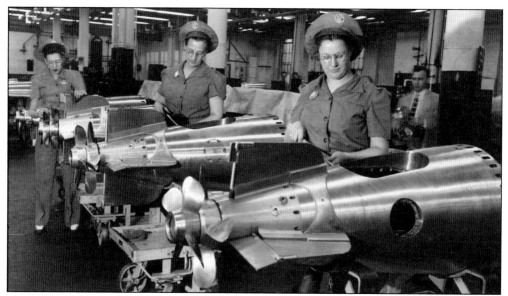

Mark XIII aerial torpedoes were mass-produced for the US Navy at International Harvester's McCormick Works on the Southwest Side of Chicago. Each torpedo weighed more than 2,000 pounds and was 13 feet long and 22 inches in diameter. (Courtesy of the Wisconsin Historical Society, WHi-63773.)

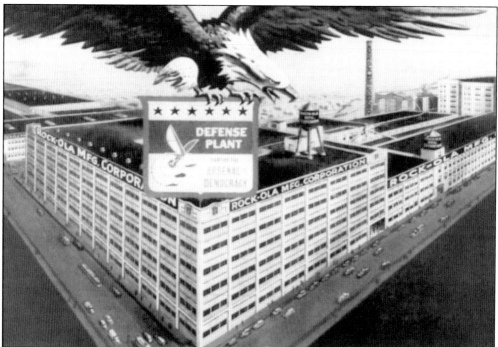

During World War II, Rock-Ola Manufacturing Corporation stopped producing jukeboxes, pinball machines, and other types of coin-operated novelties. Instead, its large factory at 800 North Kedzie Avenue turned out 30-millimeter semiautomatic carbine rifles that were widely used by the US military. The company also produced a variety of metal gun parts for other defense plants. (Courtesy of Jacob Kaplan.)

Chicago's Victor Adding Machine Company produced the important Norden bombsight that gave US aircraft unprecedented accuracy. This ad from the end of World War II explains how many smaller firms supplied hundreds of precision components for the high-tech instrument.

Putting the Rising Sun in the Shade ...Six Months Sooner!

General Motors' Buick division mass-produced Pratt & Whitney Liberator aircraft engines at a plant on North Avenue in west suburban Melrose Park. Each engine required more than 6,000 parts. Until recently, this factory was still in use producing diesel truck engines for Navistar International Corporation. (Courtesy of the Chicago History Museum, HB-06902-F, Hedrich-Blessing Collection.)

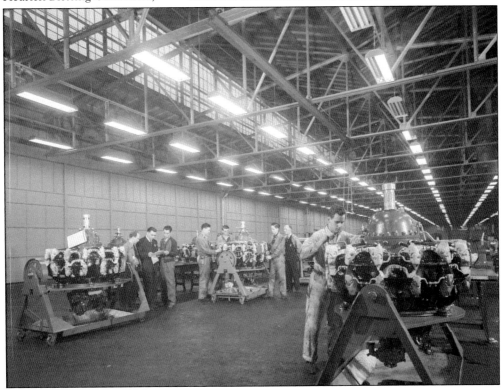

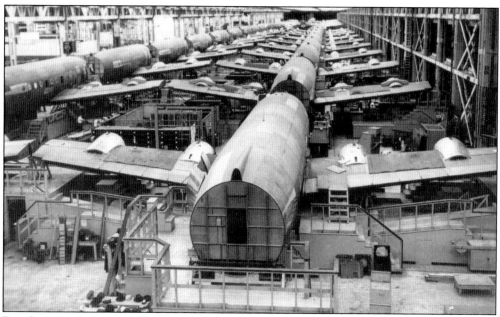

Douglas Aircraft Company built a large factory in northwest suburban Park Ridge to produce C-54 Skymaster airplanes that were used to transport military cargo and troops. The 42-acre building was made entirely of wood and employed thousands of people who built more than 650 planes. In the early 1950s, the land surrounding the factory, which included four runways, was turned into O'Hare Field. (Courtesy of Boeing.)

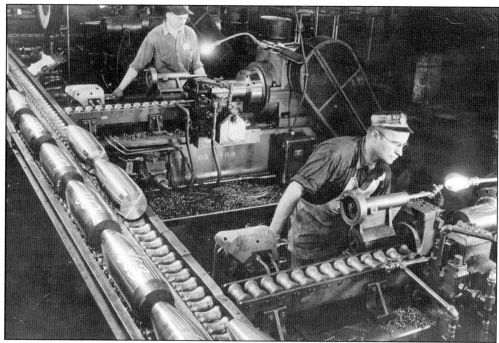

Machinists at Pullman-Standard's plant in Hammond, Indiana, mass-produced large artillery shells. The railroad car company also made cannons and tanks, in addition to wings and tails for Douglas C-54 aircraft. (Courtesy of the Pullman State Historic Site.)

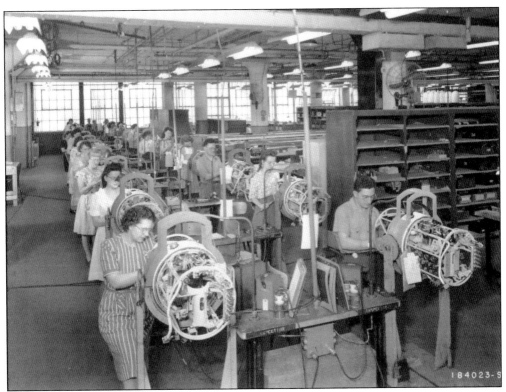

During World War II, Western Electric mass-produced a wide variety of electrical and electronic devices at the Hawthorne Works in west suburban Cicero. Products included antennas, radios, radar systems, and sonar equipment. (Courtesy of the AT&T Archives and History Center.)

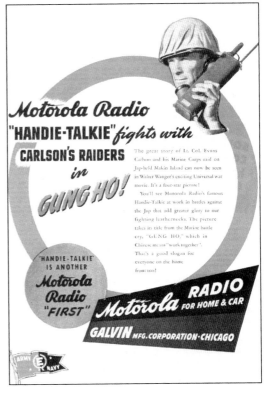

Motorola Radio "HANDIE-TALKIE" *fights with* CARLSON'S RAIDERS *in* GUNG HO!

The great story of Lt. Col. Evans Carlson and his Marine Corps raid on Jap-held Makin Island can now be seen in Walter Wanger's exciting Universal war movie. It's a four-star picture!

You'll see Motorola Radio's famous Handie-Talkie at work in battles against the Jap that add greater glory to our fighting leathernecks. The picture takes its title from the Marine battle cry, "GUNG HO," which in Chinese means "work together". That's a good slogan for everyone on the home front too!

"HANDIE-TALKIE" IS ANOTHER *Motorola Radio* "FIRST"

Motorola RADIO FOR HOME & CAR

GALVIN MFG. CORPORATION · CHICAGO

Galvin Manufacturing Corporation produced Motorola-brand portable two-way radios that soldiers called walkie-talkies. By 1947, the Motorola name was so well known that it was adopted as the name of the company.

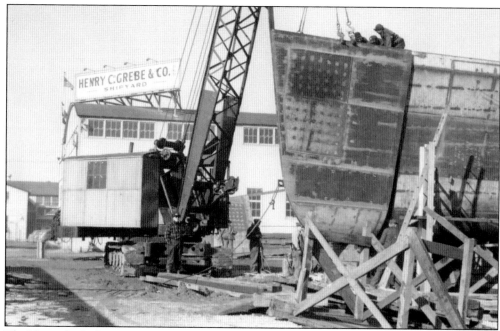

The Henry C. Grebe Company shipyard produced more than 50 vessels for the US Navy, including minesweepers, tankers, and tugboats. Finished ships were launched into the north branch of the Chicago River and then sailed down the Illinois and Mississippi Rivers to New Orleans. (Courtesy of the Chicago Maritime Museum.)

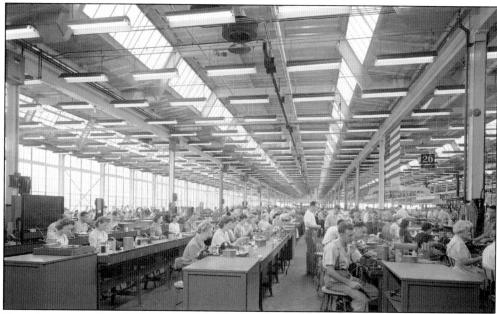

Torpedoes required hundreds of tiny, complex parts that were assembled by hand. This photograph shows a small part of the Amertorp plant on Roosevelt Road in south suburban Forest Park. This factory, set up by the American Can Company, a large manufacturer in the Chicago area, employed more than 6,000 people during World War II. More than 9,000 torpedoes were built at the factory. (Courtesy of the Chicago History Museum, HB-07313-A, Hedrich-Blessing Collection.)

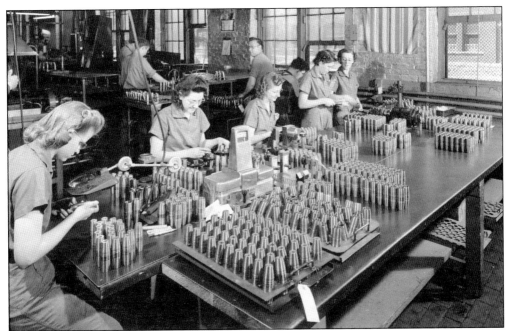

International Harvester's West Pullman Works on the South Side of Chicago mass-produced 37-millimeter cannon shells. During World War II, more than 15,000 of the company's male workers served in the military, so many factory jobs were taken over by women. (Courtesy of the Wisconsin Historical Society, WHi-26350.)

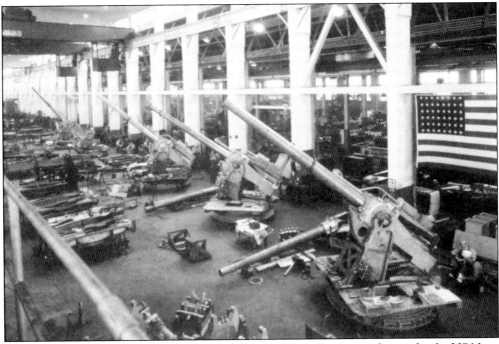

The Goss Printing Press Company produced gun mounts and antiaircraft guns for the US Navy during World War II. The overhead gantry cranes in the upper left corner were used to move gun barrels and other heavy components. (Courtesy of the Chicago History Museum, ICHi-173713.)

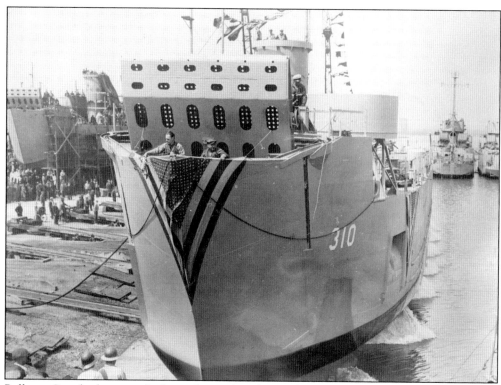

Pullman-Standard operated a large shipyard at the south end of Lake Calumet that produced patrol craft and medium landing ships (LSMs) for the US Navy. Boat sections were made at the company's 111th Street shops and then moved by rail to the shipyard, where they were welded together. The photograph shows a 203-foot-long LSM being launched in 1944. This ship, built on the South Side of Chicago, participated in military operations in the South Pacific. (Courtesy of the Pullman State Historic Site.)

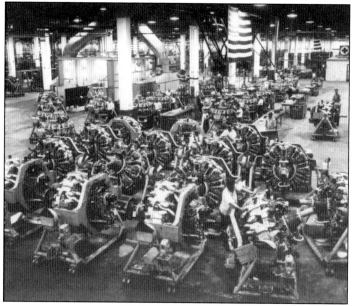

The Dodge-Chicago Plant at Seventy-Fifth and Pulaski Streets was the largest factory in the world when it was constructed in the early 1940s. The 82-acre facility occupied 30 city blocks and was operated by Chrysler Corporation. The vertically integrated factory produced more than 18,000 aircraft engines between 1943 and 1945. The 18-cylinder engines powered B-29 Super Fortress bombers. (Courtesy of FCA US LLC.)

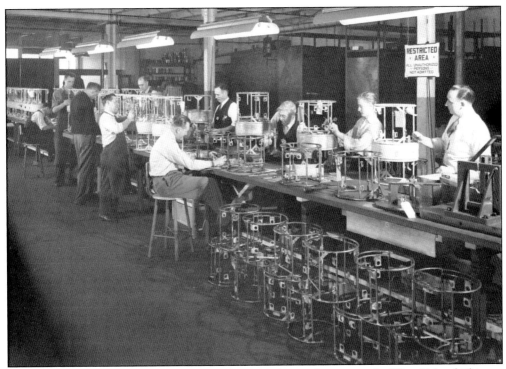

Schwinn made a few bicycles during World War II, but its factory on the West Side of Chicago focused on producing aircraft components, ammunition, artillery shell casings, and electrical devices. (Courtesy of Mark Mattei.)

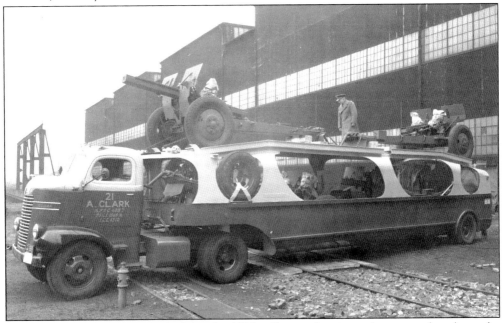

A US Army official inspects a fresh batch of 105-millimeter howitzers that are ready to leave the Pullman-Standard plant in Hammond, Indiana. An automobile carrier has been pressed into service for wartime use. (Courtesy of the Pullman State Historic Site.)

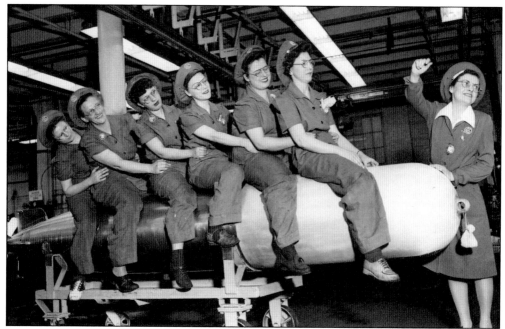

In this staged publicity photograph from 1943, several women take a rare break from assembling torpedoes at International Harvester's McCormick Works on the Southwest Side of Chicago. (Courtesy of the Wisconsin Historical Society, WHi-63769.)

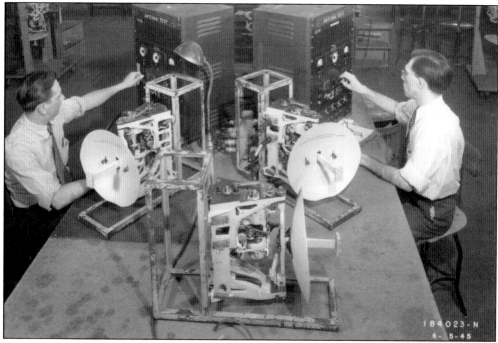

During World War II, Chicagoland companies made the majority of all electronics and communications equipment used by the US military, such as these antennas undergoing a test at Western Electric's Hawthorne Works in west suburban Cicero. (Courtesy of the AT&T Archives and History Center.)

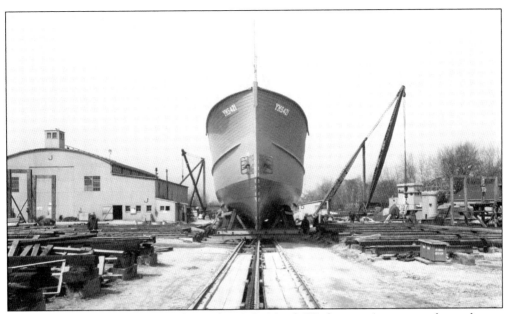

The Henry C. Grebe Company shipyard at 3250 North Washtenaw Avenue was located more than five miles up the Chicago River from Lake Michigan. Other shipyards active during the war were located on the Calumet River and Lake Calumet on the South Side of Chicago. (Courtesy of the Chicago Maritime Museum.)

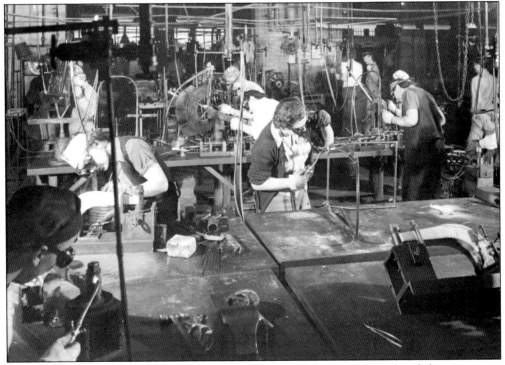

Because thousands of men were away on active military duty, women replaced them on many assembly lines. Most of the welders in this scene at the Schwinn factory are women. (Courtesy of Mark Mattei.)

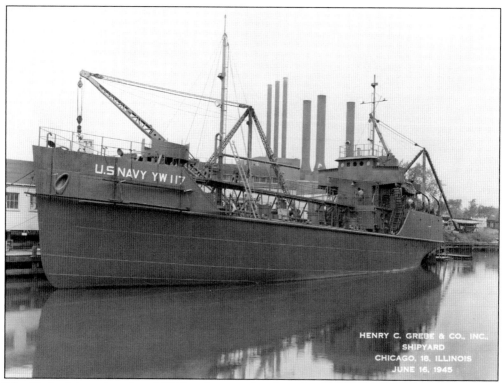

The Grebe shipyard produced 174-foot-long steel tankers for the US Navy on the North Side of Chicago. Each of the ships, which were used to refuel the fleet at sea, could carry 200,000 gallons. (Courtesy of the Chicago Maritime Museum.)

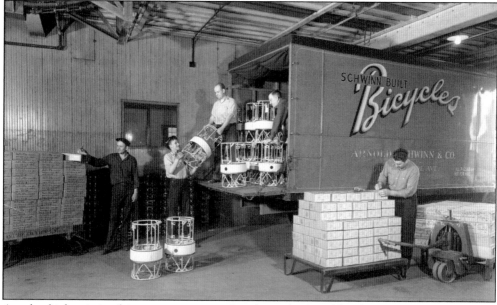

Another high-priority shipment is getting ready to leave the Arnold, Schwinn & Company factory on the West Side of Chicago. But, in less than one year, the men in this photograph will once again be loading bicycles onto this truck. (Courtesy of Mark Mattei.)

Six

CITY OF STEEL

Making steel and fabricating heavy metal objects has always been an important part of Chicago's manufacturing identity. Chicagoland once turned out steel rails that tamed the Wild West, steel beams that transformed city skylines, and girders that built bridges. Factories also mass-produced the barbed-wire fences, nails, and pipes that built America.

Stamping machines and other metal fabrication equipment turned raw steel plate into the massive parts needed to build appliances, automobiles, construction equipment, freight cars, locomotives, tractors, and trucks.

Chicago's iron and steel industry started modestly along the Chicago River in the 1850s with foundries casting parts for steam engines, stoves, and other products. The city's first rolling mill opened on the North Side in 1858 and began making rails for the booming railroad industry. By the time the Civil War started, it was producing 100 tons a day.

Five years later, Union Steel opened on the Southwest Side, followed by Chicago Iron Company in 1868 and Joliet Iron and Steel Company in 1871. Other operations included the American Iron and Steel Works at the corner of Canal and Lake Streets and the Chicago Steel Works on Noble Street.

Growing demand from local manufacturers eventually spurred these small companies to merge and expand their operations. By the 1880s, three Chicago rolling mills alone employed more than 3,000 people and accounted for almost one-third of the total US output of steel rails.

As companies outgrew their facilities, several large steel mills were eventually built on the Southeast Side of Chicago near the mouth of the Calumet River. Both sides of the river were lined with blast furnaces and rolling mills that operated 24 hours a day.

The area was dominated by U.S. Steel's South Works, which hugged the shore of Lake Michigan. But, Republic Steel, Wisconsin Steel, and Youngstown Sheet & Tube operated facilities nearby.

At its peak, the Southeast Side of Chicago employed 200,000 people in steel mills and industries related to metal fabrication. In the early 1950s, Chicago surpassed Pittsburgh as the nation's largest steel producer, with an annual output exceeding 20 million tons. As late as the mid-1970s, U.S. Steel alone employed almost 40,000 people in the Chicago area—more than any other company.

However, the sudden decline of the American steel industry in the late 1970s took its toll on many facilities. Wisconsin Steel closed in 1980 and U.S. Steel shut its doors in 1992. When the lights went out on the last blast furnace, a colorful chapter in Chicago history ended.

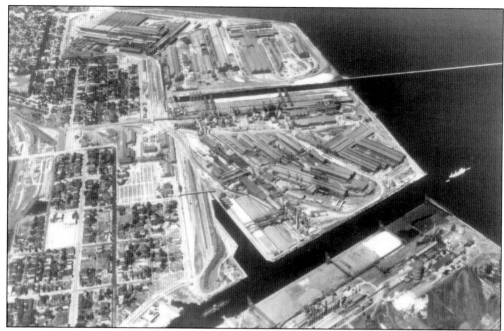

This aerial view looking north shows the immense size of the U.S. Steel South Works, which stretched along Lake Michigan from Seventy-Ninth Street to the Calumet River. The site has been abandoned since the early 1990s and is still awaiting redevelopment. (Courtesy of the Elgin, Joliet & Eastern Railway Archive.)

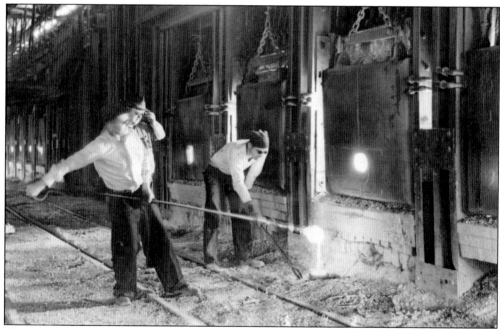

The Republic Steel Corporation mill in South Chicago was the site of a violent labor battle in 1937. On Memorial Day, a group of striking workers clashed with police in a bloody confrontation near the main gate of the steel mill. Ten workers died in the controversial incident, and 60 were injured.

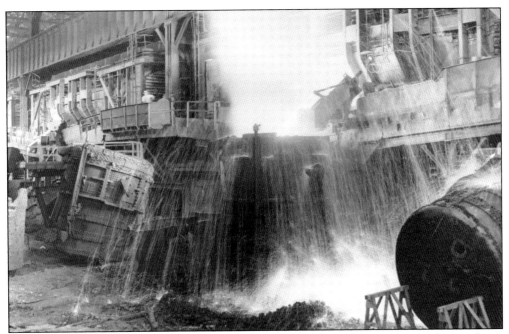

For much of the 20th century, Chicago was a major producer of iron and steel. The Southeast Side of the city was home to large mills operated by Republic Steel, U.S. Steel, Wisconsin Steel, and Youngstown Sheet & Tube.

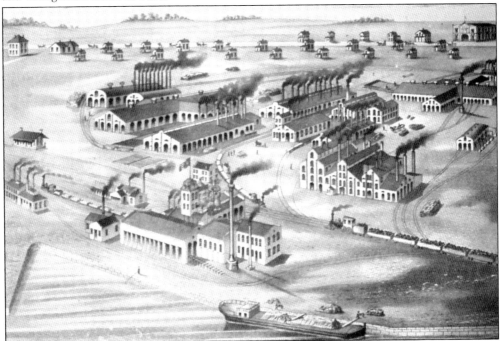

Joliet was also an important steel maker for decades, starting in the early 1870s. The Joliet Iron and Steel Company became part of the Illinois Steel Company in 1889 and was eventually absorbed into U.S. Steel Corporation. At one time, the mill was the largest nail producer in the world. (Courtesy of the Joliet Area Historical Museum.)

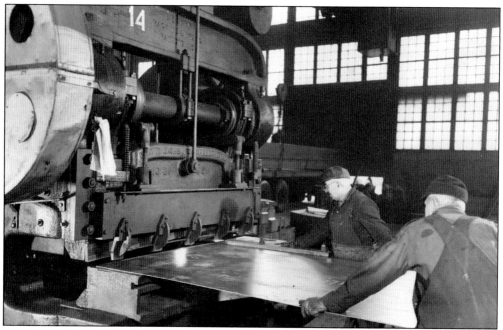

Workers at the Hansell-Elcock Company use a 72-inch plate shear machine that was made by the Beatty Machine & Manufacturing Company in nearby Hammond, Indiana. Hansell-Elcock was a top metal fabricator that specialized in structural steel used in buildings and bridges. (Courtesy of the Chicago History Museum, ICHi-173780; Kaufmann-Fabry Company, photographer.)

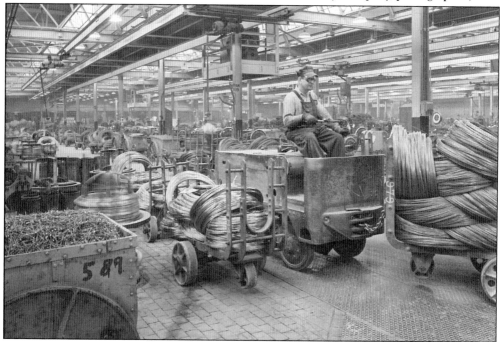

For decades, Joliet was called the "city of steel." It was a major producer of barbed wire, nails, and rods. This scene inside the American Steel and Wire Company shows heavy coils of galvanized wire being moved around the large complex. (Courtesy of the Joliet Area Historical Museum.)

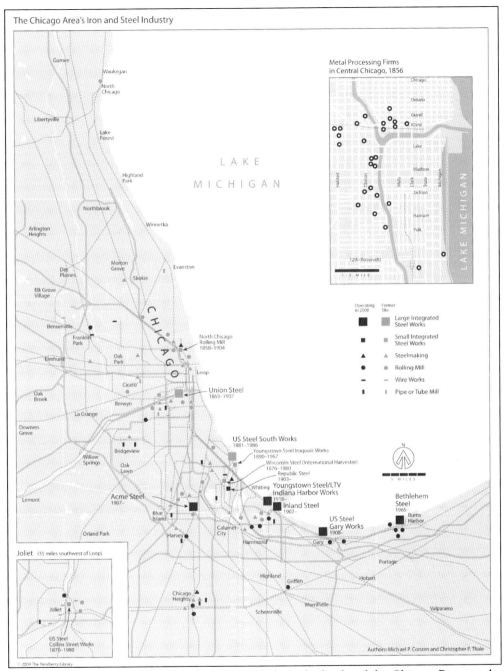

The Windy City's iron and steel industry started along the banks of the Chicago River in the 1850s. As companies outgrew their facilities, the industry moved to the Southeast Side of Chicago along the Calumet River and Lake Michigan. Today, steel production continues to thrive just over the border in northwest Indiana. (Courtesy of the Newberry Library.)

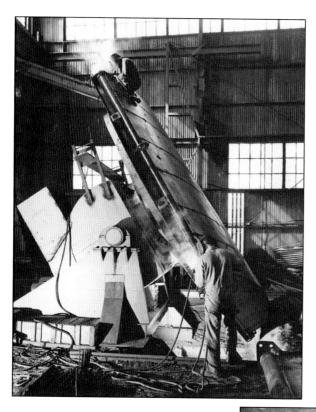

These workers at Mississippi Valley Structural Steel Company in west suburban Melrose Park are welding a large piece of a barge. The company also fabricated parts used to build many local bridges and buildings. (Courtesy of the Chicago History Museum, ICHi-173778; Fred G. Korth, photographer.)

The International Harvester Company was a vertically integrated manufacturer that even owned the ships that transported iron ore to its Wisconsin Steel Works on the Southeast Side of Chicago. The large facility supplied International Harvester's factories with steel to produce farm implements, refrigerators, tractors, and trucks.

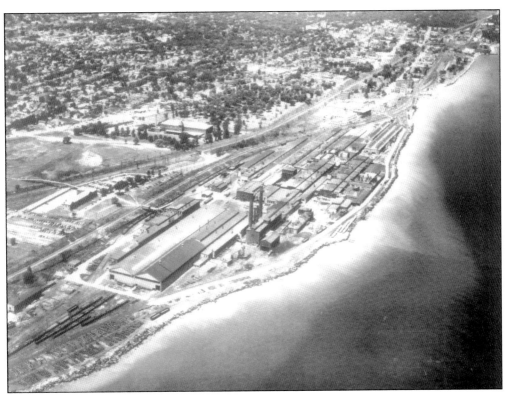

U.S. Steel's Waukegan Works was located along the shore of Lake Michigan. Downtown Waukegan is visible at the top of this aerial photograph, with a view looking north. This facility produced a wide variety of steel products, such as fencing, nails, and wire; it closed in 1979. (Courtesy of the Elgin, Joliet & Eastern Railway Archive.)

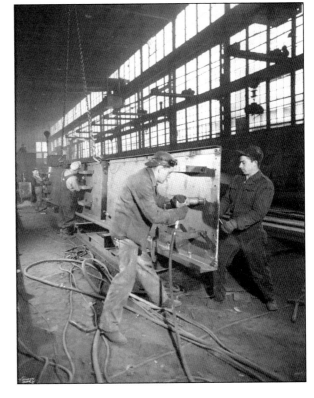

Tightening large bolts with pneumatic impact wrenches, these men are assembling a section of a sand storage bin at the Hansell-Elcock Company in the late 1940s. (Courtesy of the Chicago History Museum, ICHi-173779; Kaufmann-Fabry Company, photographer.)

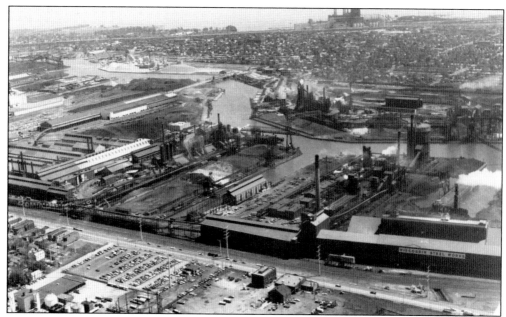

International Harvester's Wisconsin Steel Works was located along the Calumet River in the South Deering neighborhood on the Southeast Side of Chicago. In this 1970 view looking north, the Acme Steel coke plant is located on the far side of the river. Lake Michigan is visible at the top of the photograph. After 105 years of operation, the Wisconsin Steel Works closed in 1980. (Courtesy of the Wisconsin Historical Society, WHi-59695.)

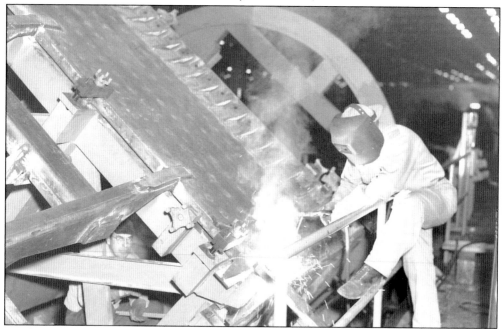

Until recently, Caterpillar operated assembly plants in west suburban Aurora and Joliet that produced excavators, scrapers, and wheel loaders. This early 1960s scene inside the four-million-square-foot Joliet factory shows a large piece of earthmoving equipment being welded. (Courtesy of the Joliet Area Historical Museum.)

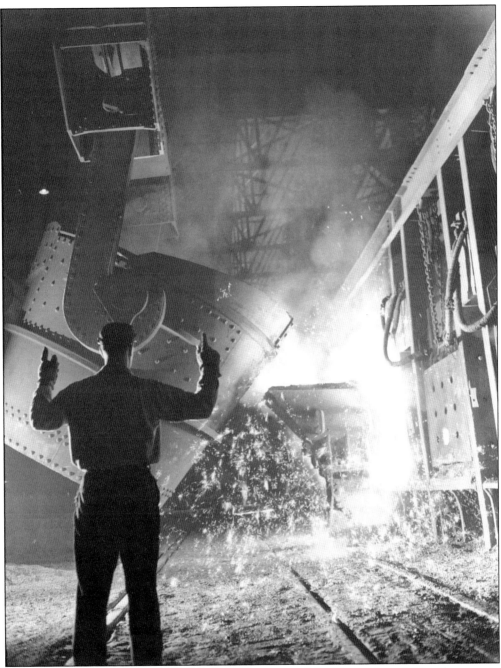

This iconic photograph from the early 1950s shows one of the 31 open-hearth blast furnaces in operation at U.S. Steel's South Works. The facility turned out steel beams and girders that were used to build numerous skyscrapers in Chicago and other cities during the 20th century. (Courtesy of the Chicago History Museum, ICHi-040192.)

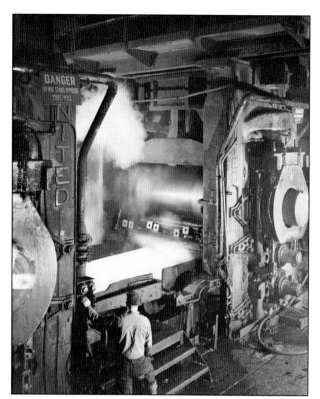

The U.S. Steel South Works occupied more than 570 acres on the Southeast Side of Chicago and was a beehive of activity for decades. At its peak in the 1940s, the steel mill employed almost 20,000 people. This view shows the continuous plate mill in action making parts for the hull of a large ship. (Courtesy of the Chicago History Museum, ICHi-021654.)

A large metal stamping machine dwarfs two employees at the Pressed Steel Car Company plant in the Hegewisch neighborhood on the South Side of Chicago. The company was a leading producer of railroad freight cars, but it also built tanks during World War II. (Courtesy of the Ryerson & Burnham Archives.)

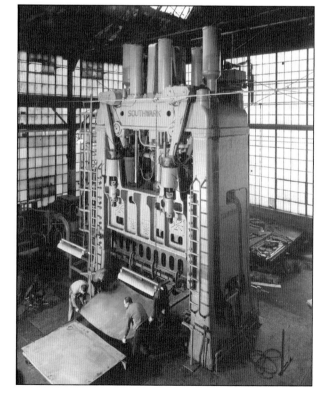

This Borg-Warner advertisement from the 1940s claims that the company's Ingersoll Steel & Disc division in West Pullman is "the world's largest producer of tillage steel for the farm implement industry." Other divisions of Borg-Warner produced auto parts, aircraft parts, and home appliances.

Scenes like this were once common throughout many Chicago factories that consumed vast amounts of metal. In this 1930 image, workers are cutting sheets of steel at International Harvester's Deering Works on the North Side of Chicago. The factory was located near the intersection of Clybourn and Fullerton Avenues. (Courtesy of the Wisconsin Historical Society, WHi-9625.)

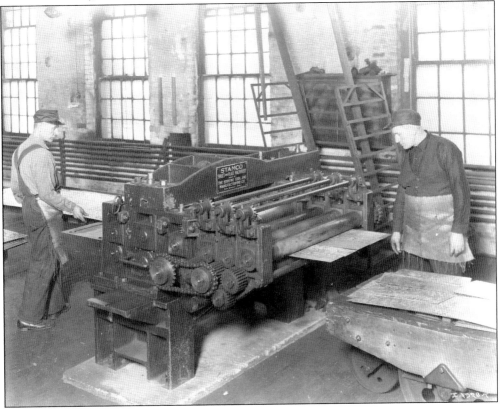

DISCOVER THOUSANDS OF LOCAL HISTORY BOOKS FEATURING MILLIONS OF VINTAGE IMAGES

Arcadia Publishing, the leading local history publisher in the United States, is committed to making history accessible and meaningful through publishing books that celebrate and preserve the heritage of America's people and places.

Find more books like this at
www.arcadiapublishing.com

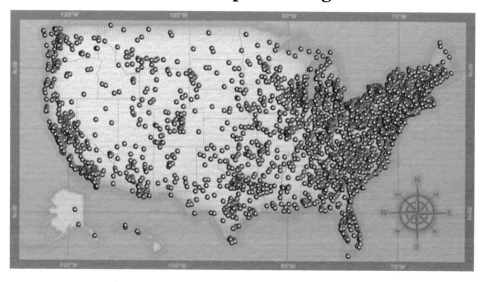

Search for your hometown history, your old stomping grounds, and even your favorite sports team.